Four colour microfic...
299 reproductions in pocket
at back of book. These can
be viewed using the microfiche
reader in the library.

TWENTIETH-CENTURY
EUROPEAN PAINTINGS

The Art Institute of Chicago

TWENTIETH-CENTURY EUROPEAN PAINTINGS

A. JAMES SPEYER

Compiled by
Courtney Graham Donnell

The University of Chicago Press

Chicago and London

This work has been made possible through the assistance of a Research Collections grant from the National Endowment for the Humanities.

Four microfiches with 299 color reproductions accompany this publication and are best viewed on a reader with a 20–24× lens.

The University of Chicago Press, Chicago 60637
The University of Chicago Press, Ltd., London
©1980 by The Art Institute of Chicago
All rights reserved. Published 1980
Printed in the United States of America

Library of Congress Cataloging in Publication Data

Chicago. Art Institute.
 Twentieth-century European paintings.
 Bibliography: p.
 1. Painting, European. 2. Painting, Modern—20th century—Europe. I. Speyer, A. James. II. Donnell, Courtney Graham. III. Title.
 ND458.C48 1980 759.06 80-18785
 ISBN 0-226-68804-6

Contents

Acknowledgments, vii
History of the Collection, 1
Comments on the Twentieth-Century European Paintings, 11
Captions, 30
Selected Bibliography, 79

Fiche Contents

Lucien Adrion, 1A1
Albert André, 1A2
Dorotéo Arnaïz, 1A7
François Arnal, 1A8
Jean Atlan, 1A9
Francis Bacon, 1A10
Enrico Baj, 1A11
Balthus, 1A12
Charles Beauchamp, 1B1
Max Beckmann, 1B2
Albert Besnard, 1B3
Christian Boltanski, 1B4
Pierre Bonnard, 1B5
Constantin Brancusi, 1B7
Sir Frank Brangwyn, 1B8
Georges Braque, 1B9
Victor Brauner, 1C1
Alberto Burri, 1C2

Heinrich Campendonk, 1C3
Georges Émile Capon, 1C4
Carlo Carrà, 1C10
Jules Cavaillès, 1C11
Marc Chagall, 1C12
Émilie Charmy, 1D5
Giorgio de Chirico, 1D6
Lovis Corinth, 1D10
Charles Cottet, 1D11
Roberto Crippa, see 1C1
Salvador Dali, 1D12
Hanne Darboven, 1E1
Robert Delaunay, 1E2
Paul Delvaux, 1E3
André Derain, 1E4
Paul Dessau, 1E12
Theo van Doesburg, 1F1
Jean Dubuffet, 1F2

Marcel Duchamp, 1F7
Charles Georges Dufresne, 1F8
Raoul Dufy, 1F10
André Dunoyer de Segonzac, 1G1
W. Russell Flint, 1G4
Jean-Louis Forain, 1G5
Tsugouharu Foujita, 1G7
Paul Gauguin, 1G8
Robert Genin, 1G9
Juan Genovès, 1G10
Alberto Giacometti, 1G11
Gilbert & George, 2A1
Edouard Goerg, 2A2
Nathalie Gontcharova, 2A6
Juan Gris, 2A7
Jean-Baptiste Armand Guillaumin, 2A12
Jean Hélion, 2B1
Auguste Herbin, 2B2
Ferdinand Hodler, 2B3
Carl Hofer, 2B6
Marcel Janco, 2B7
Alexei Jawlensky, 2B8
Charles Édouard Jeanneret (Le Corbusier), see 2D8
Augustus Edwin John, 2B10
Wassily Kandinsky, 2B12
George Kars, 2C5
Yasuo Kazuki, 2C7
Ernst Ludwig Kirchner, 2C8
Paul Klee, 2C9
Oskar Kokoschka, 2D3
Per Krohg, 2D5
Elie Lascaux, 2D7
Le Corbusier, 2D8
Fernand Léger, 2D9
Henri-Eugène Le Sidaner, 2E2
André Lhote, 2E3

René Magritte, 2E9
Mané-Katz, 2E10
Franz Marc, 2E11
Jean Hippolyte Marchand, 2E12
Louis Marcoussis, 2F1
Pierre-Albert Marquet, 2F2
Phillip Martin, 2F3
Georges Mathieu, 2F4
Henri Matisse, 2F6
Ludwig Meidner, 2G2
Jean Metzinger, 2G3
Manolo Millares, 2G6
Joan Miró, 2G7
Paula Modersohn-Becker, 2G11
Amedeo Modigliani, 2G12
Captain Edward Molyneux, 3A5
Piet Mondrian, 3A6
Claude Monet, 3A8
Gabriele Münter, 3B7
Ben Nicholson, 3B8
Emil Nolde, 3B9
Sir William Orpen, 3B10
Amédée Ozenfant, 3B12
Jules Pascin, 3C1
Victor Pasmore, 3C5
Francis Picabia, 3C6
Pablo Picasso, 3C8
Serge Poliakoff, 3E3
Pedro Pruna, 3E5
James Pryde, 3E6
Odilon Redon, 3E7
Pierre Auguste Renoir, 3E9
Bridget Riley, 3F2
Jean-Paul Riopelle, 3F3
Giovanni Romagnoli, 3F6
Georges Rouault, 3F8
Henri Rousseau (Le

Douanier), 3F12
Ker-Xavier Roussel, 3G2
Russian, Twentieth Century,
3G3
Karl Schmidt-Rottluff, 3G4
Kurt Schwitters, 3G5
Gino Severini, 3G6
Lucien Simon, 3G8
Mario Sironi, 3G9
Joaquin Sorolla y Bastida,
3G10
Pierre Soulages, 3G11
Chaim Soutine, 3G12
Amadeo de Souza-Cardoso,
4A3
Nicolas de Staël, 4A6
Kumi Sugaï, 4A7

Yves Tanguy, 4A8
Maurice Utrillo, 4A10
Félix Vallotton, 4B3
Kees van Dongen, 4B4
Victor Vasarely, 4B7
Henri Vergé-Sarrat, 4B9
Maria Elena Vieira da Silva,
4B11
Jacques Villon, 4C1
Maurice de Vlaminck, 4C3
Édouard Vuillard, 4C8
Jack B. Yeats, 4D3
Eugène Zak, 4D4
Zao Wuo-Ki, 4D5
Anders Zorn, 4D8
Ignacio Zuloaga, 4D11

vii

Acknowledgments

This project could not have been accomplished without the direct assistance and full cooperation of many departments within the Art Institute of Chicago, and we would like to take this opportunity to thank them warmly. To the extent that the project involved photographing each work in the permanent collection of the Department of Twentieth-Century Painting and Sculpture, it would have been inconceivable without the constructive assistance of the Museum Photography Department, directed by Howard Kraywinkel. We are especially grateful to the photographers who actually completed this extensive work, Elizabeth Claffey and Jerry Kobylecky. Manuscript preparation was aided by Naomi Vine, former research assistant in the Department of Twentieth-Century Painting and Sculpture, Anne Rorimer, associate curator, and the staff of the department. We add particular thanks to those donors who documented information required for the project and permitted visits to their homes for photographic needs, and to the galleries, museums, artists, and artists' families who provided valuable data and assistance.

History of
the Collection

The Art Institute of Chicago, one hundred years old in 1979, has grown from a regional museum in the American middle west to one renowned throughout the world for its collection of Western art from the Middle Ages to the present. Part of the Art Institute's international fame rests on its splendid holdings of nineteenth-century French art. Even before the turn of the century, a few farsighted Chicagoans dared to appreciate the most current trends in European art. They visited European galleries and, in many cases, the artists themselves. Chicago's civic leaders, such as Mrs. Potter Palmer and Mr. and Mrs. Martin A. Ryerson, bought Renoirs and Monets in the 1890s and later gave them to the Art Institute of Chicago. It is indeed due to the pioneering judgment and generosity of these and other patrons that the Art Institute has one of the world's great collections of Impressionist painting.

Built upon this foundation, the European painting collection has continually expanded over the years to develop a superior collection of twentieth-century art as well, and its particular strengths are its representation of Cubism, Expressionism, and Surrealism. This volume illustrates all 299 European paintings accessioned through 1978. Many of them have not been reproduced before, and a number are acquisitions made after 1961, when the last general catalog, *Paintings in the Art Institute of Chicago*, was published.

Early in the museum's history, the Department of Painting and Sculpture included works from all eras and was supervised by the director, who also served in the capacity of curator. Wil-

1

liam M. R. French, brother of the American sculptor Daniel Chester French, was the museum's first professional director; he served from 1888 to 1914, and was succeeded by George W. Eggers, director from 1916 to 1921. As the collections were being built, acquisitions in the field of European painting centered on the work of the Old Masters; a particularly notable purchase was the Demidoff Collection, fifteen paintings acquired in 1890 through the efforts of Mr. Ryerson, Mr. French, and the museum's president, Charles L. Hutchinson. The only contemporary art acquired at that point was American. The Art Institute supported the work of living American artists through its annual American exhibition, a tradition that began in 1888 and continues today, and through a group called Friends of American Art, which purchased works for the permanent collection. The modern European collection was slower to grow. In fact, this catalog shows only two contemporary European paintings accessioned between 1900 and 1920, salon pieces by Joaquin Sorolla y Bastida and Sir William Orpen.

Meanwhile, some intrepid Chicago businessmen—industrialists, politicians, stockbrokers, and lawyers—privately began assembling for themselves collections of works by the European avant-garde. Their loyal support of the city's growing art museum and their gestures of patronage became a tradition. Many individual artworks and occasionally entire collections were given to the Art Institute, and thus, the museum's collection reflects a wide variety of taste and holds a diversity of artwork representative of the trends of the earliest part of the century through the most recent activity. In its eclecticism, the collection includes both masterpieces and curiosities. In some cases, one can follow the sequence of an artist's work over a period of years; in others, one finds isolated, single works of high quality; one sees, as well, rarities from artists once held in high esteem but over the years perhaps forgotten.

Even in the early period, Chicago felt the impact of one of the most influential art events of the twentieth century. After its opening in New York in February 1913, the "International Exhibition of Modern Art" (the Armory Show) came to the Art Institute of Chicago in March 1913. Brought to the midwest at the urging of Arthur Aldis, a Chicago lawyer, collector, and museum trustee, and Arthur Jerome Eddy, also a Chicago

2

lawyer and collector, the Armory Show exhibited the most advanced artworks by both European and American artists. The public and press controversies that had accompanied this great exhibition in New York continued without abatement in Chicago. Students at the School of the Art Institute even burned an effigy of Henri Matisse, whom they dubbed "Henry Hair-Mattress." After all, the Chicago public had seen mainly conservative trends in art two decades earlier at the World's Columbian Exposition of 1893. The Art Institute's director, Mr. French, who was not overly sympathetic to the cause of modern art, found it convenient to leave on vacation before the opening of the Armory Show in Chicago. But a guarded defense of the exhibition appeared in the museum's *Bulletin* of the next month: "Question has been raised in some quarters whether the Art Institute does right in exhibiting the strange works of the cubists and post-impressionists. . . . The policy of the Art Institute, however, has always been liberal, and it has been willing to give a hearing to strange and even heretical doctrines, relying upon the inherent ability of the truth ultimately to prevail." Several adventuresome Chicago collectors, such as Mr. Eddy, bought works out of the exhibition, some of which were later given to the museum and are to be seen today in the collection.

A strong emphasis on modern European art began with the directorship of Robert B. Harshe, an amateur painter himself, who held the double post of director and curator from 1921 to 1938, and this continued to an even greater degree under Daniel Catton Rich, curator of painting and director of fine arts from 1938 to 1958. The generosity of some Chicagoans began to enrich the permanent collections of the Art Institute in the field of avant-garde European art. In 1921, Joseph Winterbotham (1852–1925), a Chicagoan engaged in the cooperage business, made an extraordinary gift of funds to be applied specifically toward the purchase of modern paintings by foreign artists, until the collection reached thirty-five in number. An exceptional aspect of the Winterbotham plan allows sale or exchange of these paintings at any time, should the curator and the Winterbotham Committee make such a decision. Selection of paintings for the Winterbotham Collection began in the 1920s and reached the total of thirty-five in 1947. The flexibility of the

plan has resulted in changes in this collection's contents over the years. Today, the Winterbotham Collection includes many of the museum's most significant modern European works and is exhibited as a unit once a year.

The first large collection of modern European art to enter the museum in toto came in 1926 from the Chicago painter and museum trustee, Frederic Clay Bartlett (1873–1953), as a memorial to his second wife, Helen Birch Bartlett. Always shown together in one room at the museum, this spectacular collection contains twenty-three paintings, eight of which are late nineteenth-century works, including Seurat's masterpiece *Sunday Afternoon on the Island of La Grande Jatte,* and the remainder, works of the twentieth century. In advance of accepted taste, Mr. and Mrs. Bartlett assembled a collection in the 1920s that reflected a belief in the value of art being produced in France in the last years of the nineteenth and first decades of this century. It is reported that his gift was taken somewhat grudgingly by the museum's trustees, but it provided the first paintings by Pablo Picasso, Amedeo Modigliani, Henri Matisse, and André Derain to go on permanent display at the Art Institute. The Helen Birch Bartlett Memorial Collection became the first gallery emphasizing post-Impressionist European art in a major American museum. In fact, this remarkable display, which was in existence three years before New York's Museum of Modern Art was formally opened in 1929, established a precedent for future developments at the Art Institute of Chicago.

In 1931 the scope of the European collection was enlarged into the realm of Expressionism through the gift of twenty paintings (and three sculptures) in the Arthur Jerome Eddy Memorial Collection. A pioneer in many ways, Mr. Eddy (1859–1920) had his portrait painted by Whistler and his bust sculpted by Rodin, and he wrote the first comprehensive book in English on Cubism. He was among the first Americans to purchase works by Wassily Kandinsky, and four of these paintings came to the museum upon the death of Mr. Eddy's widow, along with examples of work by such other Expressionist artists as Franz Marc and Gabriele Münter. Several of the paintings Eddy bought from the Armory Show are now in the museum's permanent collection; these include three by the little-known Portuguese painter, Amadeo de Souza-Cardoso,

and works by Derain, Maurice de Vlaminck, André Dunoyer de Segonzac, Émilie Charmy, and Eugène Zak.

The year 1933 became an extraordinarily productive one for the arts in Chicago. It marked the largest single bequest of artworks ever to have come to the Art Institute, as well as the broadest survey of painting and sculpture to have been on exhibition. The Ryerson bequest of more than two hundred paintings as well as Oriental and decorative arts came to the museum at the death of Martin A. Ryerson (1856–1932), one of America's great connoisseurs. For nearly half a century, he served the museum in various capacities. In 1890 he became a trustee and in 1925–26 served as honorary president. Most of the Ryerson paintings were from preceding centuries, but they did include works by Monet and Renoir and Impressionist followers Albert André, Jean Marchand, and Albert Marquet for the twentieth-century collection. At this same time a bequest from Mrs. Lewis Larned Coburn (1856?–1932), whose modest apartment in a Chicago hotel had been filled with her magnificent pictures, added late works by the Impressionists, a still life by Odilon Redon, and an early work by Picasso.

The Art Institute's "Century of Progress Exhibition of Painting and Sculpture" was held in 1933 during the Chicago World's Fair. The Art Institute was designated as the fair's official Fine Arts Department, and the exhibition celebrated one hundred years of American collecting by bringing together twelve hundred paintings, watercolors, drawings, and sculptures lent from private and public collections in America. Although the survey, which one critic at the time called "the finest art exhibition ever held in America," began with thirteenth-century European paintings, there was substantial representation by European and American artists of the twentieth century, much of it from the Art Institute's own holdings. The exhibition was planned by the Art Institute's director, Robert B. Harshe (1879–1938), and the catalog was edited by Daniel Catton Rich (1904–76) at the beginning of his long and distinguished career. A similar undertaking occurred the following year, when in 1934 another "Century of Progress Exhibition" featured a survey of American painting, of which the Art Institute's permanent collection formed the core. It might be said that the two "Century of Progress" exhibitions firmly

established the reputation of the Art Institute as an early leader in the presentation of outstanding loan exhibitions, offering the public an opportunity to see both the historical and the current in art.

The permanent European collection was augmented further in the thirties by the addition of more than twenty-five paintings by contemporary artists as gifts from the collection of Carter H. Harrison (1860–1953), a former mayor of Chicago. During frequent trips to Europe and visits to the Paris art galleries, Mr. and Mrs. Harrison acquired works by André Lhote, Maurice Utrillo, Jules Pascin, and Kees van Dongen as well as by artists less well-known today, such as Georges Capon, Per Krohg, George Kars, and Henri Vergé-Sarrat. In this same decade, purchases for the Joseph Winterbotham Collection brought paintings by such diverse artists as Marc Chagall, Giorgio de Chirico, Raoul Dufy, Chaim Soutine, and Oskar Kokoschka, and the museum received its first painting by Fernand Léger (in 1937) as a gift from Charles H. and Mary F. S. Worcester, Chicago collectors. By the end of the thirties, the collection had achieved a fine representation of major trends in twentieth-century European painting, and the Art Institute of Chicago had become one of the leading repositories of modern French art in the country.

After the intervening years of World War II, gifts further benefitting the twentieth-century European collection came in the late forties and early fifties. The first of these was again from Charles H. and Mary F. S. Worcester. Mr. Worcester (1864–1956), who was an amateur painter and a museum trustree, often collected with the needs of the museum in mind and when he and his wife presented seventy paintings, drawings, and sculpture in 1947, they included early Italian and German works along with French and American paintings of the nineteenth and twentieth centuries, with an endowment fund for future purchases of art. Contemporary works from the Worcesters by Matisse, Modigliani, Soutine, Derain, and Édouard Vuillard were combined with more conservative paintings by Orpen, Augustus John, and Jean-Louis Forain. In 1950, the Kate L. Brewster (1879?–1947) bequest brought to the Art Institute many of the fine nineteenth- and twentieth-century paintings, drawings, and sculpture that Mrs. Brewster and her husband,

Walter S. Brewster (1872?–1954), a trustee and later vice-president of the museum's board, had assembled over a period of twenty-five years. In the realm of early twentieth-century French art, these included a Picasso head from his Blue Period and abstractions by Juan Gris, Léger, and Amédée Ozenfant. In 1954, Joseph Winterbotham, Jr. (1879–1954), left a bequest, which added paintings by Charles Georges Dufresne, Dufy, de Chirico, and Modigliani, among others.

In order to organize and manage a now sizable modern collection of both European and American art and to stimulate future growth, an advisory committee on twentieth-century painting and sculpture was established and in 1954 a curator was selected to supervise that portion of the museum's collection. First to hold this curatorship was Katharine Kuh. A whole new generation of collectors began to lend their support to the museum, and this, combined with Mrs. Kuh's dynamic and effective leadership, resulted in major acquisitions during her tenure. In the field of European painting these included the Picasso *Mother and Child* of 1921, a gift from a group of Chicagoans in 1955, which is a pivotal work in the sequence of nineteen Picasso paintings in the collection, ranging in date from 1901 to 1959; the spectacular canvas of 1913, *Edtaonisl*, by Francis Picabia; Matisse's *Bathers by a River*, completed in 1916–17, the most important of eight paintings by Matisse in the museum; *Head Surrounded by Sides of Beef* (1954), by Francis Bacon; a self-portrait by Max Beckmann of 1937, and many other significant works.

Although the new generation of Chicago collectors chose broadly for their private collections, their individual benefactions in the field of twentieth-century European painting during the fifties and early sixties showed a continued preference for French art. Gifts from Mrs. Gilbert W. Chapman, who was president of the progressive Arts Club of Chicago in the 1930s, included work by Matisse, Chagall, Jean-Paul Riopelle, Georges Rouault, and the outstanding Cubist portrait by Picasso of his dealer, Daniel-Henry Kahnweiler, painted in 1910, as well as a composition of 1935 by Piet Mondrian. The first work by the French artist Jean Dubuffet to enter the collection came as a gift from Mr. and Mrs. Maurice E. Culberg in 1950, and after Mr. Culberg's death in 1953, two other Dubuf-

7

fets were given to the Art Institute by the artist himself in memory of this Chicago collector. The Culbergs were also responsible for important works by Chagall, Paul Delvaux, Léger, Joan Miró, and Vlaminck in the collection, all donated in the short period from 1950 through 1953. Other active patrons at this time were Mr. and Mrs. Samuel A. Marx, whose gifts before Mr. Marx's death in 1964 included three significant paintings by Picasso and works by Matisse, Miró, and Rouault. Since 1950, Mr. and Mrs. Leigh B. Block have been responsible for extraordinary gifts to many departments of the museum, but most especially to the European area of the twentieth-century collections. Foremost among these gifts from the Blocks have been the Cubist portrait of Picasso by Juan Gris, an early oil by Paul Klee, figure compositions by Picasso, Modigliani, Alberto Giacometti, and Rouault, a still life of 1929 by Léger, and works by painters of the new School of Paris.

At the end of the fifties, both Mr. Rich and Mrs. Kuh left the museum after their many years of distinguished service. In surveying this era of the museum's history many years later, the eminent late museologist Charles C. Cunningham (1910–79), director of the Art Institute of Chicago from 1966 to 1972, commented in the foreword to the catalog *The Art Institute of Chicago* (1970): "Rich's term as director, from 1938 to 1958, brought many firsts to Chicago, but perhaps his greatest contribution was that, working with his staff, he assembled the finest twentieth-century collection to be housed in a general museum in the United States." In 1959, the late John Maxon (1916–77), author of the catalog, became Mr. Rich's successor as director of fine arts. From 1966 until his death in 1977, Mr. Maxon served as the museum's associate director and as vice-president for collections and exhibitions.

In 1961, A. James Speyer became curator of Twentieth-Century Painting and Sculpture, a post he still holds. In 1962 he installed the major portion of the twentieth-century European collection in the new gallery spaces of a wing donated by the Sterling Morton family of Chicago, patrons of long-standing, where it is displayed today. The goals of the department during this time have been to strengthen the European painting collection with works by earlier masters of the twentieth century and to build up the collection with outstanding art by more contem-

8

porary painters—those who emerged after World War II in Europe up to the present.

Historical works have today become scarcer and harder to secure. Fortunately, however, the twentieth-century department has been aided in this pursuit by benefactors who have continued their patronage, by the support of new friends, and by funds that have been directed to this department. A recent bequest (1978) from Maxine Kunstadter (Mrs. Sigmund Kunstadter), of Chicago, added paintings to the European collection by artists such as Louis Marcoussis, Maria Elena Vieira da Silva, and Jack B. Yeats. Other enthusiasts of contemporary art, such as Mr. and Mrs. Solomon B. Smith, Mr. and Mrs. Edwin E. Hokin, and Mr. and Mrs. Neison Harris, have recently been instrumental in augmenting the permanent collection. In 1964 the Grant J. Pick Bequest provided the most important gift of money that the department has ever received to be used exclusively for the acquisition of twentieth-century art. The highly significant Pick Collection consists of painting and sculpture from America and Europe, and the most notable European painting acquired was the Picasso *Nude under a Pine Tree* (1959). In 1940, a support group of the museum called the Society for Contemporary American Art was formed to assist in buying works by current American artists for the permanent collection. This group developed into a major force in augmenting the museum's collections and in 1968 it voted to change its bylaws to include European art. Today the focus of the Society for Contemporary Art is international and an outstanding example of Optical art, *Ascending and Descending Hero* (1965), a painting by the British artist Bridget Riley was the first gift of a European artwork from the group.

A small discretionary fund, called the Twentieth-Century Purchase Fund, was instituted in 1969 to permit the curator to acquire experimental and advanced works of art without committee approval. This modest purse has allowed significant acquisitions in the realm of contemporary art, such as pieces by the French artist Christian Boltanski and by the British artists Gilbert & George. In 1977, the twentieth-century department at the Art Institute of Chicago organized the first large group exhibition in an American museum to present the work of a new generation of European artists. This exhibition, called "Europe

9

in the Seventies: Aspects of Recent Art," stimulated subsequent additions to the collection of European art from the 1970s. These recent acquisitions symbolize a liberal policy, signaled perhaps in 1913, to show Chicago what is contemporary in art. Throughout the century daring steps taken by patrons and staff of the Art Institute of Chicago have given the museum's twentieth-century collection its rich legacy and the promise of a great future.

COURTNEY GRAHAM DONNELL

Comments on the Twentieth-Century European Paintings

Gifts and purchases over the years have made the European painting collection of the Art Institute of Chicago an outstanding repository of twentieth-century art. Within a general survey of this period, the contents of the collection especially emphasize the areas of Cubism and Surrealism as well as Expressionism and to a lesser extent the post–World War II School of Paris. At the museum the present installation of the twentieth-century European galleries is to be found in the Morton Wing, arranged chronologically, beginning with the year 1900. The only exception is the Helen Birch Bartlett Memorial Collection which is hung separately according to the terms of gift. Despite the large spaces of the Morton Wing, the entire collection of 299 paintings cannot be displayed at all times.

The turn of the century marks a pivotal point in the history of art. The fame of the Impressionists and post-Impressionists was already established. Van Gogh had died in 1890 and Seurat in 1891; Cézanne and Toulouse-Lautrec were living out their last years; Gauguin retired to the island of Dominique in the Marquesas, where he died in 1903; after 1900 Degas lived as a recluse, troubled by failing eyesight, until his death in 1917; and although Monet and Renoir painted for many years in the new century, their great artistic statements had been made. The intensity of the Symbolist movement had also dissipated, but the many distinguished painters of the late nineteenth century in France had set the stage for the revolution of modernism.

Their contributions led away from the traditional subject

11

matter and officially sanctioned painting technique taught in the academies. The Impressionists painted directly out-of-doors. They painted the effects of light on objects within their sight to produce entirely new optical sensations. Their choice and presentation of the subject was by previous standards shockingly unconventional, and the post-Impressionists—Cézanne, Toulouse-Lautrec, and van Gogh—carried this aspect even further while also increasing the radical exaggerations of pigment and freedom of line. In the late 1880s and 1890s other artists, such as Gauguin and his circle, Redon, and the Nabis, showed a common tendency, now usually labeled as Symbolism, toward expression of inner thought and mood through a freer use of the physical properties inherent in painting. The work of all these artists followed a path away from the academic and literal toward increasing abstraction and personal expression, thus preparing a foundation for the artistic innovations of the twentieth century.

This transitional period in France directly after 1900 is well illustrated in the Art Institute's twentieth-century collection through late paintings by Monet, Renoir, Gauguin, and Redon and works by the younger generation of painters such as Vuillard, Bonnard, Roussel, and Vallotton. Eleven works by Claude Monet, painted in 1900 and after, follow upon the magnificent sequence of Impressionist works by Monet in the museum's Earlier Painting Department. Among those illustrated in this volume are two studies of Vétheuil of 1901 (3A10, 3A11) and *Iris by the Pond* (3B6), which Monet finished around 1925, the year before his death. Five paintings by Auguste Renoir, done after the turn of the century, are included here and complement a group of fifteen earlier works in the museum's nineteenth-century collection. Two of the illustrated five, including a portrait of the artist's son Jean (3E9), are dated close to 1900, and the other three were painted in the last decade of Renoir's life, between 1916 and 1918 (3E11–3F1). Of the seven remarkable paintings by Gauguin at the Art Institute, *Tahitian Woman with Children* (1G8), dated 1901, is illustrated in this volume; it was painted when Gauguin was about to leave Tahiti for his destination in the Marquesas. The Symbolist painter Odilon Redon is represented by two works, one a provocative mythological scene, *Andromeda* (c. 1905–8; 3E7), and the other, one of his

great still life subjects, *Vase with Flowers* (c. 1910; 3E8). The collection holds an unusual work of 1908 by Carlo Carrà, *Horsemen of the Apocalypse* (1C10), which predates Carrà's involvement in the Italian Futurist movement and shows instead his emergence from Symbolism.

Seven paintings dating from 1900 to 1935 by Édouard Vuillard are part of the collection. Vuillard was an original member of that significant group, active for a short time at the turn of the century, which called itself the Nabis (the Hebrew word for "prophet"). One of these paintings is a still life, *Les Boules de neige* (1905; 4C11), while all the others are variations of the intimate and sensitive interior scenes that established his reputation. Two late works by Vuillard's brilliant contemporary, Pierre Bonnard, are in the collection (1B5, 1B6) as well as works by other Nabi painters: Ker-Xavier Roussel's luxurious *Flowers* of 1904 (3G2), and the odalisque painted in 1911 by Félix Vallotton (4B3).

An eclectic collection such as this in the Art Institute of Chicago has the power to illustrate a range of artistic accomplishment through paintings assembled over many years—from masters of a period to talents in fashion at one time. A touted acquisiton of 1912 was *Woman in Gray* (3B11), painted in 1908 by the Englishman Sir William Orpen. In 1921, the museum purchased a fine self-portrait by the French artist Lucien Simon (3G8), and in 1925 a portrait of the actress Consuelo by the Spanish artist Ignacio Zuloaga (4D11). Interestingly, portraits of both Monet and Renoir, done in 1912 and 1914 (1A4, 1A6), are among the five works in the collection by their less eminent Impressionist colleague, Albert André. There are other paintings by a later generation of Impressionists, such as Guillaumin and Le Sidaner, works by the British painter Augustus John, by the Swedish artist Anders Zorn, who was especially popular in Chicago at the turn of the century, and by the Spaniard Joaquin Sorolla y Bastida, who spent two months in Chicago in 1911 for an exhibition of his work and a visiting professorship at the museum's school.

The development of modernism in art occurred in Europe as a result of many aesthetic, political, philosophical, and social factors and expressed itself in rich and varied forms in different countries in the beginning decades of the century. The radical

13

innovations in color, form, and content, which revolutionized painting in this period, were given such now familiar labels as Fauvism, Cubism, Expressionism, Dadaism, and Surrealism.

In 1905 an important exhibition was held in Paris when a room at the Salon d'Automne was set aside for the work of several unfamiliar artists. These centered around a leader, Henri Matisse, and included André Derain, Maurice de Vlaminck, Georges Rouault, Albert Marquet, Kees van Dongen, and Georges Braque, among others. Their chief identification at the time was experimentation with pure and brilliant colors vigorously applied on canvases that showed the artist's highly personal response to subject matter, continuing and carrying further the ideas of their Impressionist and post-Impressionist predecessors. This was an idea so shocking that the group was labeled the Fauves (or "wild beasts"). A fine example of this movement in the Art Institute's collection is Maurice de Vlaminck's *Houses at Chatou* (4C8), painted in 1905–6, the peak of the Fauve period, while Matisse's painting of 1906, *Still Life with Geranium Plant and Fruit* (2F7), is less exaggerated in color but has the unexpected perspective and abbreviated suggestions of form that distinguished Fauvism from previous artistic expressions, both academic and Impressionist.

Fauvism as a movement lasted only until about 1908, but Matisse developed into one of the leading artists of the twentieth century. No less than that other master of this time, Pablo Picasso, Matisse evolved over the years a distinctive idiom on the highest level, in painting, sculpture, drawing, and graphics, which established his eminent reputation. He is represented in the Chicago collection by eight paintings. Of special importance are the *Apples* (1916; 2F8), the monumental canvas *Bathers by a River* (2F9), one of the key works in Matisse's oeuvre (one of his own most enigmatic and a landmark of the period), *Interior at Nice* (1921; 2F11), the view from his room on the French Riviera, and *Woman before an Aquarium* (1923; 2F12).

It is possible to follow later developments in the art of others who participated in the first Fauve exhibition. There are eight paintings by Derain—from the early, highly mannered *Forest at Martigues* (1908–9; 1E4), through an important transitional work of 1911, *Last Supper* (1E6), which shows his struggle with a less than profound conviction of Cubism, to the latest of

his works in the collection, modest landscapes which almost return to earlier nineteenth-century expression (1E11). Four paintings by Vlaminck in the collection postdate his Fauve period and show his brief flirtation with Cubism and later more conventional still lifes and landscapes (4C4–4C7). The work of Georges Rouault can be seen in four paintings dating from 1912 to 1937 (3F8–3F11). Rouault's typically critical commentary on the state of society is clearly evident in the bold and satirical figures of *The Academician* (1912–13; 3F8) and *The Three Judges* (1928; 3F9); these images are rendered in his virtuoso technique in rich earth colors and impasto. There are three paintings by Kees van Dongen, the witty Fauve painter who moved to Paris from Holland in the 1890s; all of these are later works (4B4–4B6), decorative glimpses of life in Montmartre and Montparnasse before and after World War I. Georges Braque, of course, distinguished himself only a few years after the first Fauve exhibition as one of the originators, with Pablo Picasso, of Cubism, and with each later progression of his personal style.

Pablo Picasso first left Spain to visit Paris in 1900; three years later he returned to stay. Picasso's paintings in the Art Institute's galleries illustrate many aspects of his rich career. The sequence begins with two post-Impressionist paintings of 1901, *On the Upper Deck (The Omnibus)* (3C8) and *Woman with Cats* (3C9). Next come the pensive works of Picasso's Blue Period, the blind, emaciated figure of *The Old Guitarist* (1903; 3C10), and the portrait of a beautiful circus character who played a major role in this early period, *Head of an Acrobat's Wife* (1904; 3C11). In Paris, Picasso met Georges Braque and began working with him in 1908. Their experiments, lasting until 1914, resulted in an entirely new concept of painted volume and space and established Cubism as the vital revolutionary force in early twentieth-century painting.

While the Cubists developed from Cézanne and were influenced by primitive art, the utterly original outcome of their investigations was a change so dramatic in the artist's approach to vision and construction that it presented a drastic challenge to the viewer's acceptance of their images. The term *cubism* is said to have come from a critic's description of a 1908 exhibition of Braque's work, described as *bizzareries cubiques* and reinforced by a phrase attributed to Henri Matisse also describing

Braque's work as made of *petits cubes*. The term seems suitable indeed to apply to the earliest works in this style by Picasso and Braque, when they abstracted recognizable subjects in terms of geometric volumes such as cubes, cones, prisms, and pyramids and used earth tones as their palette, progressing eventually into infinitely more complicated variations.

The Art Institute of Chicago's collection contains a superior survey of Cubist works by Picasso and Braque, Juan Gris and Jean Metzinger, Louis Marcoussis, Robert Delaunay, Jacques Villon, Francis Picabia, Gino Severini, Joan Miró, Fernand Léger, and others who were inspired by the activities in Paris. Two key, early Cubist paintings in the collection, from 1909, are Picasso's *Head of a Woman* (3D1) and Braque's *Harbor in Normandy* (1B9). Both of these paintings show application of Cubist theory and color on traditional subject matter—portraiture and landscape. An important example of the second phase of Cubism, commonly called Analytic Cubism (dating from 1910 to 1912), is Picasso's superb portrait, *Daniel-Henry Kahnweiler* (1910; 3D2), in which the figure, rendered in a range of monochromatic tones, emerges from an intricate construction of planes that dissect the subject from multiple angles, seen simultaneously. A counterpoint to the portrait of Kahnweiler is Gris's *Portrait of Picasso* (2A7), painted in 1912, showing this artist's more systematic, static, and decorative approach to Cubism. In about 1912 both Picasso and Braque introduced the new element of collage into their work, incorporating actual bits of paper, newspaper, wallpaper, and lettering into their drawings and paintings. This device ultimately evolved into *trompe l'oeil* configurations of collage painted on canvas and was adopted by other artists involved in the Cubist movement, such as the Polish emigré Louis Marcoussis, whose small painting *La Mominette* (1912; 2F1) illustrates just such an interest.

Brilliant variations of Cubism followed, such as Robert Delaunay's *Champs de Mars, The Red Tower* (1911; 1E2), Jacques Villon's *Musical Instruments* (1912; 4C1), Francis Picabia's *Edtaonisl* (1913; 3C6), and Metzinger's *Woman with Fan* (1913; 2G4), and they show the great impact of this movement at its height. In addition, three paintings by the rarely shown Portuguese artist Amadeo de Souza-Cardoso, who lived in Paris from 1906 to 1914, show a particularly idiosyncratic combination

16

of Cubism and fairy tale folk art (4A3–4A5). The Art Institute follows the course of Cubism into the twenties, and Picasso's *Man with Pipe* (3D3) demonstrates the brighter chromatic patterns and flatter treatment of volumes of the so-called Synthetic phase of Cubism in 1915, while two still lifes (3G6, 3G7) of 1916 and 1918 by the Italian artist and leader in the Futurist movement, Gino Severini, show his later accomplished versions of Cubist style. Information of the art world and excitement of Paris reached Joan Miró in Spain early in his career, although he did not come to France until 1919. His *Portrait of a Woman (Juanita Obrador)* (1918; 2G7) presents Miró's distinctive version of Cubism battling with Spanish traditional forms. Fernand Léger shows his unique modification of Cubist principles in four paintings dating from 1919 to 1928. They include a small study for his central theme, the series on the city, *Follow the Arrow (Study for the Level Crossing)* (1919; 2D9), and the brilliantly colored still life, *The Red Table* (1920; 2D10), leading into the increasingly abstract painting of mechanical elements to be observed in *Composition in Blue* (1921–27; 2D11). Léger's development from Cubism to abstraction is further illustrated in *Nature Morte tricolore* (1928; 2D12), which uses literal, figurative elements in new combination. Again, through the work of lesser-known artists, such as André Lhote, the dilutions and vagaries of Cubism can be followed with interest. Lhote's six paintings in the collection are landscapes and portraits dated 1914 to 1930. A variant of Cubism, which was labeled Purism in 1918 by its founders, Amédée Ozenfant and Le Corbusier (Charles Édouard Jeanneret), is represented by the tiny but exemplary *Landscape* (3B12) of 1918 by Ozenfant and the study *Abstract Composition* (1927; 2D8) by the architect-painter Le Corbusier.

Pablo Picasso's work reflected constant change and fluctuation in style throughout his long life. His brilliance was not contained by dogma. Always allied with real subject matter, he varied his interpretations from the most abstract to the elusively natural. His distortions of nature have, in fact, become so much a part of our visual vocabulary that their form of exaggeration has become assimilated. In the early 1920s he began a new interest in the figure, and in 1921 he painted the Art Institute's monumental *Mother and Child* (3D4), a noble, neoclassical composition with overwhelming interest in the volumetric figure.

17

Originally, the painting contained the additional figure of a man at the left of the canvas, but later Picasso removed this section. In 1969, he rediscovered the fragment (3D5) and presented it to the museum. Cubism did not encompass everyone who was working in Paris during this time. Certainly the work of Henri Rousseau (Le Douanier) is in a category all its own. Two of his late paintings in the twentieth-century collection illustrate his intense purity of expression, as in *Flowers* (c. 1905; 3F12) and particularly in *The Waterfall* (1910; 3G1), with its fantastic images from nature. Although Rousseau was born a generation earlier than Matisse or Picasso, his naive spirit and imagination gave him a special acceptance among the initiators of modernism. The Italian artist Amedeo Modigliani was another painter very much accepted by the advanced coterie of international artists in Paris. Modigliani made his home there after 1906, and of the five paintings in this collection—all portraits—*Madam Pompadour* (1915; 2G12), *Jacques Lipchitz and His Wife* (1916; 3A1), and *Woman with Necklace* (1917; 3A3) are outstanding. Four paintings of 1913 to 1920 by Maurice Utrillo depict his favorite subject material, the streets of Montmartre (4A10–4B1) while the work of the Bulgarian emigré Jules Pascin is represented by four soft, atmospheric portraits (3C1–3C4), dating from 1907 to 1927.

In Russia a few enlightened artists and collectors followed the developments in Europe, especially in France. An ample artistic exchange through journals and exhibitions spurred changes in Russian art from academicism toward new abstraction. One of the leading figures in this movement was Nathalie Gontcharova, whose *Spanish Dancer* (c. 1916; 2A6) was probably painted the year after she left Russia for travels in Italy and Spain and the year before she settled in Paris. A double portrait, possibly depicting Gontcharova and Michael Larionov (3G3), another Russian artist of great importance, was acquired by the Art Institute in 1975; the authorship of the painting, as well as its date (c. 1910), have been problematic.

As the developments described above were taking place in France, other paths were followed in the north of Europe, particularly the Germanic countries. Artistic activity in the north during and after the period of post-Impressionism differed from the manifestations in France, and this is evident in the

works of two painters born in the 1850s, Ferdinand Hodler in Switzerland and Lovis Corinth in Germany. The two portraits and a landscape by Hodler in the Art Institute's collection (2B3–2B5) dating from 1907 to 1917, show an emphasis on contour, spatial flatness, and pale coloration reached in the late works of this romantic and philosophical Swiss painter. A painting of 1917 in the collection is one of many self-portraits by Lovis Corinth (1D10). Shortly after the turn of the century, Corinth was one of the most influential artists in Germany, when, painting in the Impressionist mode, he became a leader in the Berlin Secession group. Although at first Corinth was an opponent of the rising contemporary movements, his self-portrait of 1917 indicates his later acceptance of German Expressionism, for which his art had actually been an important precursor.

While artists in Paris were exhibiting the first Fauve canvases, a group of young artists in Dresden, led by Ernst Ludwig Kirchner, formed an association in 1905 called Die Brücke. As the name implied, this group—one of the two most revolutionary groups of artists in northern Europe in the early part of the century—sought to connect the artistic traditions of the northern countries with their own innovations, "bridging" the gap with the northern style known as German Expressionism. Their philosophy was rooted in medieval and Renaissance German art with the additional influence of primitive art, and they were keenly aware of contemporary ideas in France, not least the emergence of Fauvism. In their daring attempts to convey the direct manifestation of emotions in art, they employed for their canvases exaggerated color, bold application of paint, and consciously primitive presentation of form. Even after a move to Berlin in 1911, Die Brücke retained an identity until the start of the First World War. The Art Institute's collection holds works by three artists of Die Brücke: Karl Schmidt-Rottluff's *Girls in a Garden* (1914; 3G4), Emil Nolde's *Figure with Flowers* (1915; 3B9), and Ernst Ludwig Kirchner's *Mountain Valley with Huts* (1917–18; 2C8).

The other influential group in the north was Der blaue Reiter, ("The Blue Rider"), formed in Munich in 1911. This association revolved around the ideas and personality of Wassily Kandinsky and was supposedly named after the title of one of his paintings. Kandinsky, born in Russia, became an impos-

ing figure in art of the twentieth century. He started painting in a naturalistic manner, inspired by folk art. Over a period of years his painting underwent a drastic transformation, resulting in what is frequently considered the first abstract painting, a watercolor of 1910. In the collection of the Art Institute are five paintings by Kandinsky that exactly cover this period of transition. One is a small, naturalistic landscape of 1904, *Kallmünz* (2B12) while others show his advance toward nonrepresentation, from the assimilated folk art roots of *Troika* (1911; 2C1) and *Landscape with Two Poplars* (1912; 2C2) to two of his mature abstract series, *Improvisation No. 30* (1913; 2C3) and *Improvisation with Green Center* (1913; 2C4), composed of shapes and colors filled for Kandinsky with emotional and spiritual meaning carried beyond any literal representation.

Franz Marc was the co-editor of the yearbook of Der blaue Reiter. His painting of 1913 in the Art Institute's collection, *The Bewitched Mill* (2E11), combined quasi-Cubist forms with his personal direction in Expressionism, his symbolic color, and his geometricized subject matter from nature. The collection contains works by other artists who were members of Der blaue Reiter: Gabriele Münter's *Still Life with Queen* (1912; 3B7) and Heinrich Campendonk's *Landscape* (1917; 1C3). Alexei Jawlensky, still another Russian artist who lived in Germany, was not an official member of Der blaue Reiter although he participated in their exhibitions as a close associate of Kandinsky. About 1910 he began painting portrait heads—as in the Art Institute's *Girl with the Green Face* (2B8)—a subject which became primary in his work and was to grow increasingly abstract, as evidenced in the head painted seven years later, *Mittlere Kopfe Nr. 1 (Andrej)* (2B9). Der blaue Reiter ceased to exist as a group at the beginning of World War I, but like the artists of Die Brücke, many of its members continued to work and develop individually for years afterward.

Other artists responded to the emotional spirit and style of Expressionism without belonging to either formal group. The work of Paula Modersohn-Becker is usually associated with Expressionism, although the Art Institute's *Still Life* (2G11) of about 1900 is closer to the decorative characteristics of Jugendstil, to which she adhered at an early point in her career. The distortions of form in Ludwig Meidner's tortured *Portrait of*

Max Hermann-Neisse (1913; 2G2) exemplify that artist's analytical examination of his subjects. Two paintings by the great Austrian Expressionist Oskar Kokoschka are in the collection, one an early psychological study, *Portrait of Ebenstein* (1908; 2D3), and the other a painting showing the more lavish brushwork of his later landscape style, *Elbe River near Dresden* (1919; 2D4). Carl Hofer showed with the Expressionists but did not claim to be one of them, and his *Girls Throwing Flowers* (1934; 2B6) typifies his seductive, superficial style.

Marc Chagall, born in Russia, worked in Paris from 1910 to 1914 and again in the 1920s after an intervening trip to his homeland during the war years. The prodigious output of this artist, who eventually made France his home, is a combination of influences from his Russian-Jewish heritage, Cubism, Expressionism, and his own fantastic imagery. The five paintings by Chagall in the Art Institute's collection span the years 1911 to 1943 and include *Naissance* (1911; 1C12), a reminiscence of his childhood, reflecting incipient Cubist influence, *The Praying Jew (Rabbi of Vitebsk)* (1D1) an example of his full Cubist period, conceived in 1914 and executed in 1923, and *The Circus Rider* (c. 1927; 1D2), which presages his later direction.

While the impact of Cubism was being experienced in France and Expressionism in Germany, the Dutch were developing a style based on abstraction through geometry. The chief theoreticians of the de Stijl movement in Holland around 1915 were Piet Mondrian and Theo van Doesburg. Based primarily upon mathematical and philosophical precepts, their idea was to unite all artists toward a common goal: the simplification and abstraction of art forms. The straight line became of utmost importance in their process of abstraction, which Mondrian eventually termed Neo-plasticism, and by the 1920s their works reached the simplification visible in Mondrian's *Diagonal Composition* (1921; 3A6) and van Doesburg's *Counter-Composition VII* (1924; 1F1) in the Art Institute's collection. These are complemented by Mondrian's *Composition Gray-Red* (3A7) of 1935, a good example of his middle style.

By the end of World War I, a number of the younger generation of artists and thinkers in Europe were in revolt against the attitudes they believed had led the world into conflict. Beginning actually before the war ended, about 1916, their explora-

tions away from traditional and even modernist art forms into automatism and dream imagery, stimulated by the discoveries of Freud in the area of the subconscious, created two of the most important art movements of the twentieth century: Dada and Surrealism. The Dada (essentially a nonsense word which can only be translated equivocally as "hobbyhorse") movement, encompassing writers and artists, originated in Zurich and manifested itself in outrageous artistic and literary activity, as well as live public demonstrations (imbued with wit but conspicuously lacking logic or reason) to signify the group's disdain for preceding art forms. An international leader of this anti-art movement was Marcel Duchamp, who in 1916 put together his first "ready-mades," which were cleverly constructed assemblages of commonplace objects. An early painting by Duchamp in the Art Institute's collection, *Nude in a Bathtub* (1910; 1F7), shows a calm naturalism influenced by post-Impressionism, which was soon to be supplanted, however, by Duchamp's inventive explorations of the limits of art. Dadaism spread to other cities in Europe, particularly Cologne and Hannover, where in 1919 Kurt Schwitters created his *Merzbilder* ("junk pictures") from bits of paper and objects found at random. Although the formally organized Dada movement lasted only until the mid-1920s, Schwitters's work remained essentially the same throughout his career. The Art Institute's collection has a late example by Schwitters, an oil and collage on canvas of 1942, *Aerated VIII* (3G5), combining his favorite objects—railway tickets, receipts, labels, and newspaper clippings. Dada was introduced into still other European cities and the United States as well, until in 1924 it was superceded by the Surrealist movement.

The term Surrealism was used initially by Guillaume Apollinaire in 1917 in the program introduction he wrote for the ballet "Parade." Whatever its initial context, the word soon covered several new directions in art. These related to the disruptive spirit of Dada, to the Freudian investigation of dreams and the subconscious, and to experimentation with automatism in art and literature. The majority of artists who created images "more real than real" painted in a highly finished, sharply focused technique, which infused the bizarre elements their paintings usually contained with familiar qualities and posed a perceptual dilemma to the viewer.

The first Surrealist group exhibition took place in 1925 in Paris and was an important international event showing works by the Italian Giorgio de Chirico, the German Paul Klee, and the Spaniards Miró and Picasso, among others. Later to join the group were the French artists Yves Tanguy, Duchamp, and Picabia, the Spaniard Salvador Dali, and the Belgians, René Magritte and Paul Delvaux. The Art Institute's European collection has outstanding examples of Surrealist paintings from the twenties, thirties, and forties, representing a variety of subject matter, media, and style within the Surrealist idiom.

De Chirico's *The Philosopher's Conquest* (1914; 1D6) belongs to that significant earlier time in the artist's career which has been termed his metaphysical period; the painting's strange contents, dreamlike aura, and disquieting perspective link it to later Surrealist paintings in the collection, such as Dali's disturbing landscape *Inventions of the Monsters* (1937; 1D12); Magritte's *Time Transfixed* (1938; 2E9), a characteristically improbable juxtaposition of subject matter, in this instance a train engine and fireplace, and Delvaux's *The Village of the Mermaids* (1942; 1E3), an assembly of mysterious women seated by the ocean. Picasso's relation to Surrealism is shown in the threatening forms of *Head* (1927; 3D7) and *Abstraction (Background with Blue Cloudy Sky)* (1930; 3D8). Three works by Miró from the 1930s show his own witty kind of Surrealism and include the large *Personages with Star* (1933; 2G8) and the assemblage of feathers and painted sandpaper, *Homme, femmes et taureau* (1935; 2G9). The art of Paul Klee is impossible to classify with any one group; he had been associated with Der blaue Reiter and the Dada movement in his early days, but is often thought to have been primarily a Surrealist. The paintings by Klee in the Art Institute's collection cover two decades and only begin to suggest the wide diversity of his media and style. Klee's *School House* (1920; 2C9), on the one hand, is Expressionist in its feeling of toylike, primitive subject matter, and painterly surface. *Harmonisierte Gegend* (1938; 2C12), on the other hand, is a pure abstraction of painted squares. *Dancing Girl* (1940; 2D2) is one of the artist's last paintings, a gesticulating figure floating on a mysterious, atmospheric background. A very different variant of Surrealism is presented in the paintings of Tanguy. *Rapidity of Sleep* (1945; 4A8) and *Ajourer les étoiles* (1951; 4A9) are typical of his personal vocabulary—

barren, lunar landscapes peopled by biomorphic creatures. Work by the contemporary French artist Balthus still bears a strong relationship to Surrealism. The provocative, introspective nature of his nymphet subjects and their surroundings is present in the enigmatic figure painting *Patience* (1942; 1A12).

Although certain styles were dominant between the wars, many artists working in Europe in that period were not specifically identified with earlier movements or with the current stylistic groups. For instance, Chaim Soutine, the Lithuanian artist who moved to Paris in 1913, had a strong individual approach to Expressionism. This characteristic is especially apparent in the macabre still life *Dead Fowl* (c. 1926; 4A1) and in the near-demented landscape *Small Town Square, Vence* (1929; 4A2). Sharp contrast and further testimony to diverse painting activity in France are provided by three decorative landscapes of the twenties and thirties painted by Raoul Dufy (1F10–1F12), and two still lifes of this same period by André Dunoyer de Segonzac (1G2–1G3). Among the intriguing curiosities in the collection are five paintings done in the 1920s by the little-known French artist Georges Émile Capon (1C4–1C8), four by Edouard Goerg (2A2–2A5), two scenes of Italy by Henri Vergé-Sarrat, painted in 1936 (4B9–4B10), and two paintings of 1929 and about 1930 by Per Krohg, a Norwegian artist who worked in Paris (2D5–2D6). The work of Pablo Picasso continued to develop during this time. The collection holds two fine paintings of the thirties by Picasso, *The Red Armchair* (1931; 3D9) and *Still Life in Front of the Window* (1934; 3D10). The further variety to be observed in the collection is illustrated by three very different works, all from the year 1938: Jean Hélion's geometric abstraction *Twin Figures* (2B1), Braque's intricate, lyrical late Cubist still life *Fruits and Guitar* (1B11), and Chagall's *White Crucifixion* (1D3), an emotional response to the plight of the German Jews at the beginning of World War II.

The total disruption of the Second World War and the Nazi threat to individual freedom pervaded the visual arts as well. Hitler's regime exerted control over cultural affairs by labeling the works of all the advanced artists "degenerate," forbidding exhibition, and halting their activity. For this reason many artists came from Germany and the occupied countries to work in the United States during the war. These "artists in exile" in-

24

cluded Ozenfant, Chagall, Léger, Duchamp, Dali, Mondrian, Tanguy, and Max Beckmann, among others. Some later returned to Europe; Mondrian died in New York before the war ended; others remained in the United States and became American citizens. Our *Self-Portrait* by Beckmann (1B2) is dated 1937, the year he left Berlin for Amsterdam (finally to emigrate permanently to the United States ten years later). Léger lived and taught in America from 1940 to 1945. His *Divers on a Yellow Background* (2E1) was painted in 1941 and is part of a series nostalgically inspired by swimmers he saw in the port of Marseilles as he was departing for America. In 1939 Tanguy left France for the United States, where he remained until his death in 1955. Chagall was in the United States from 1941 to 1948 and painted *The Juggler* (1D4) in 1943 in New York.

In France after the war, the most influential figure to emerge in art was undoubtedly Jean Dubuffet. His first one-man exhibition was held in 1944 and since then he has been increasingly productive. He called his early style *l'art brut* ("raw art"), and he painted with the dregs of natural materials: sand, ashes, and dirt, to produce surface textures from real life. At other times, Dubuffet "painted" with butterfly wings, dried flowers, herbs and feathers—all of these materials evocative of nature in its range from the ugly to the beautiful. The Art Institute's collection holds five paintings by Dubuffet from his early to his most recent period. These include the coarsely painted head of *Jules Supervielle* (1947; 1F2); a landscape and a skyscape from the 1950s, painted during his so-called cosmological period (1F3, 1F4); *Genuflexion of the Bishop* (1963; 1F5), one of the most important early paintings in the "L'Hourloupe" series (subsequently to occupy Dubuffet for another decade); and the most recent acquisition, *La Chasse au trésor* (1978; 1F6), from the series called "Théâtres de memoire," which brings together his entire artistic past.

Many of the leading artists who had made their mark in Europe before the start of the war continued afterward to produce significant work, Picasso in particular. Three portraits of women seen in combination with *The Red Armchair* of 1931, already mentioned, reveal the continuing creativity of this artist who worked with unadulterated concentration and energy until his death in 1973. These portraits are *Seated Woman (Femme*

assise) (1949; 3D11), *The Reader (La Lecture)* (1953; 3D12), and *Sylvette (Portrait of Mlle D.)* (1954; 3E1). The latest painting by Picasso in the collection is the monumental figure composition, *Nude under a Pine Tree* (1959; 3E2), one of the outstanding paintings executed by Picasso during the short period he lived in the exotic, gloomy chateau of Vauvenargues in Provence.

The momentum of artistic innovation shifted at mid-century from Paris to New York (spurred on in part by the influence of those European artists who had taken refuge in this country). Although New York served as the new, postwar art center, contemporary European trends were not neglected in the Art Institute's collection. In particular, artists of the new generation of the School of Paris have a rather substantial representation. All of these artists were born in the twentieth century, and as in the past, following the call of Paris, many emigrated from other countries. Their work is somewhat related to the Abstract Expressionist movement generated in the United States at the same time and is characterized by a rich painterly abstraction which proliferated into a conspicuously decorative style. Their work ranges from thick, gestural application of paint, to broad flat planes of color, from calligraphy to exercises in pure Optical Art. These artists always maintained a disciplined approach to abstract composition in spite of the fact that some called their work *l'art informel* (a term coined by a French critic, meaning "spontaneous" or "formless"), *un art autre* (coined by the same critic, meaning "other art"), or *tachisme*, (from the French word for "spot" or "blot").

In the collection, for example, are an early work by Russian-born Nicolas de Staël entitled *Composition* (1946; 4A6); three paintings of the 1950s by the Canadian-born artist Jean-Paul Riopelle (3F3–3F5); two paintings, from 1954 and 1960, by Serge Poliakoff, another Russian-born artist (3E3, 3E4); three works painted in the fifties by Zao Wuo-Ki, born in Peking (4D5–4D7); two canvases by Georges Mathieu of 1951 and 1957, *Matité* (2F4) and *Fourth Avenue* (2F5); a work of 1960 by Pierre Soulages (3G11); and two paintings of the sixties by the Hungarian-born Optical artist, Victor Vasarely (4B7, 4B8). Related work of other artists painting in Paris during this time can also be seen in the collection—by Maria Elena Vieira da Silva, Jean Atlan, Kumi Sugaï, and François Arnal.

The painting collection holds some examples of art practiced elsewhere on the continent during these decades after World War II: from Spain, Millares's *Cuadro 62* (1959; 2G6) and Genovés's *Angulo 18°* (1967; 1G10) and from Italy, Sironi's *Composition* (1949; 3G9) and Burri's *Bianco* (1952; 1C2). Neo-Dada trends are shown in the jointly painted work by the Rumanian Victor Brauner and the Italian Roberto Crippa, *Prelude to a Synthesis* (1959; 1C1) and the work of the Italian Enrico Baj, *Parade* (1963; 1A11).

From postwar Great Britain, prominent abstract artists of three different generations are represented. Ben Nicholson's paintings and bas-reliefs were acclaimed soon after the First World War and he has become one of the outstanding abstract painters of his time. In the Art Institute's painting collection is Nicholson's impressive abstraction of a landscape, *November 1956 (Pistoia)* (1956; 3B8). The work of the sculptor-painter Victor Pasmore follows in the constructivist tradition with a gravure on painted wood, *Linear Development No. 1* (1965; 3C5). The large painting *Ascending and Descending Hero* (1965; 3F2) is a key example of the visual illusions created by the premier Optical artist, Bridget Riley.

One of the leading figure painters in England after the war years was Francis Bacon. In the 1950s he became involved in a series of studies after Velasquez's *Portrait of Pope Innocent X*, a fine example of which is *Head Surrounded by Sides of Beef* (1954; 1A10). This mystifying vision is one of a number of paintings of tormented, deranged figures, himself or others, which characterize Bacon's great oeuvre. Also interested primarily in the figure was the Swiss artist Alberto Giacometti, who worked for years in Paris and has been equally well-known for both painting and sculpture since he was first noticed as an associate of the Surrealists at the end of the twenties. The Art Institute owns two of Giacometti's portrait paintings, one of 1956, *Isaku Yanaihara* (1G11), and the other of 1962, *Caroline* (1G12). The quality of Giacometti's paintings is directly related to his sculptural techniques in clay, a construction of painted slashes to form the basically monochrome picture.

It is always more difficult to evaluate the art of one's own time than of preceding historical periods. A multitude of artists, their work, and art events proliferate and just as easily may

vanish from the scene. Even with increased avenues for international communication, an assessment of the most contemporary European art is especially difficult because of lack of exposure and receptivity in the United States to the current work of European artists. However, in the recent past, the Art Institute of Chicago has mounted two exhibitions which brought—with unusual impact—the work of European artists to audiences in Chicago and elsewhere. The first of these, held in 1974 in conjunction with a Marcel Duchamp retrospective exhibition (to show Duchamp's effect on his successors, both European and American) was called "Idea and Image in Recent Art." The second, mentioned previously, took place in 1977 and included only the work of European artists from the 1970s. Three works were acquired for the permanent European painting collection from these exhibitions: Boltanski's *Detective* (1972–73; 1B4); *Seven Panels and Index* (1973; 1E1), by the German artist Hanne Darboven, and *The Alcoholic* (1978; 2A1), by Gilbert & George.

Artists in their search for new form and statements in visual art have extended the boundaries of what has previously been defined as painting or sculpture. The three acquisitions mentioned above are examples of a recent trend called Conceptual Art, existing both in Europe and America. The term has been used since the late 1960s to describe art that stresses the significance of the idea in a work of art and releases traditional restrictions on resulting physical form. Conceptual Art has an almost infinite number of manifestations—among them, earthworks, body art, information systems, performance, and documentation of the foregoing through text, photographs, and video. The reader will find that Boltanski's *Detective* is a panoramic visual experience consisting of magazine photographs rather than a traditional oil painting on canvas. Darboven's *Seven Panels and Index* is a wall piece derived from the artist's private system of symbols, an intricate network of repetition and progression carried out in graphite on paper, her own schematic handwriting replacing the brush stroke. Gilbert & George actually call themselves "living sculptors"; using the medium of photography, their work consists of presenting themselves in various arrangements and situations, creating a two-dimensional record of activity from life.

The collection of modern European paintings in the Art Institute of Chicago has been built over three-quarters of a century, a period of the most rapid changes in aesthetic outlook. The works illustrated in this catalog are an impressive record of the intensity and diversity of artistic activity from the beginning of the century to the present.

A. James Speyer

Captions

Measurements in most cases were made according to dimensions of the back of the stretcher, height preceding width; where it was not possible to secure accurate measurements from the back, sight measurements were used and are so indicated. Measurements were made in inches and were mathematically converted to centimeters using the factor 2.54 cm. = 1 in.

1A1 LUCIEN ADRION, French, 1889–1953

Place de l'Opéra, Paris, c. 1924–25

Oil on panel, 23¼ x 28¾ in. (59.1 x 73 cm.)
Signed lower left: "Adrion"
Gift of Joseph Winterbotham, 1954.1352

1A2 ALBERT ANDRÉ, French, 1869–1954

Woman Reading before a Window, 1903

Oil on paper, mounted on canvas, 21¾ x 12⅝ in. (55.1 x 32.1 cm.)
Signed lower right: "Alb. André"
Mr. and Mrs. Martin A. Ryerson Collection, 1937.1013

1A3 ALBERT ANDRÉ

Anduze, 1910

Oil on paper, mounted on canvas, 18⅞ x 24½ in. (48 x 62.2 cm.)
Signed lower right: "Albert.André"
Mr. and Mrs. Martin A. Ryerson Collection, 1933.1103

1A4 ALBERT ANDRÉ
Claude Monet, 1912
 Oil on canvas, 51⅜ x 38⅜ in. (130.5 x 97.5 cm.)
 Signed lower right: "Albert André"
Stickney Fund, 1923.149

1A5 ALBERT ANDRÉ
Autumn Morning, 1913
 Oil on canvas, 28 x 35⅝ in. (71.1 x 90.5 cm.)
 Signed lower right: "Albert André"
Gift of Mrs. Bruce Borland, 1953.339

1A6 ALBERT ANDRÉ
Auguste Renoir, 1914
 Oil on canvas, 31⅞ x 26 in. (81 x 66 cm.)
 Signed lower left: "Albert André"
Stickney Fund, 1921.76

1A7 DOROTÉO ARNAÏZ, Spanish, b. 1936
El Director, 1964
 Oil on canvas, 57½ x 44⅞ in. (146.1 x 114 cm.)
 Signed center right: "ARNAÏZ"; signed, dated, and ti-
tled on verso
Gift of Miss Margaret Fisher, 1965.363

1A8 FRANÇOIS ARNAL, French, b. 1924
Les sombres fêtes de la chair, 1957
 Oil on canvas, 55 x 78⅝ in. (139.7 x 199.7 cm.)
 Signed and dated lower right: "Arnal 57"; signed,
dated, titled, and inscribed on verso
Gift of Mr. Fred Wacker, Jr., 1959.17

1A9 JEAN ATLAN, Algerian /French, 1913–60
Agrigente, 1959
 Oil on canvas, 51¼ x 32 in. (130.2 x 81.3 cm.)
 Signed and dated lower right: "Atlan 59"; signed,
dated, and titled on stretcher
Gift of Mr. and Mrs. Edwin E. Hokin, 1966.375

1A10 FRANCIS BACON, British, b. 1909
Head Surrounded by Sides of Beef, 1954

Oil on canvas, 51⅛ x 48 in. (129.9 x 121.9 cm.)
Not signed
Harriott A. Fox Fund, 1956.1201

1A11 ENRICO BAJ, Italian, b. 1924

Parade, 1963

Oil and collage on cloth, 64⅞ x 86½ in. (164.8 x 219.7 cm.)
Signed lower right: "baj"
Gift of Paride Accetti, 1967.163

1A12 BALTHUS (COUNT BALTHASAR KLOSSOWSKI DE ROLA), French, b. 1908

Patience, 1943

Oil on canvas, 63½ x 64⅜ in. (161.3 x 163.5 cm.)
Signed and dated lower left: "Balthus 1943"
Joseph Winterbotham Collection, 1964.177

1B1 CHARLES BEAUCHAMP, British, b. 1949

Self-Portrait, 1972

Oil on canvas, 63⅝ x 45 in. (161.6 x 114.3 cm.)
Not signed on recto; signed, dated, titled, and inscribed on verso
Neison and Bette Harris Acquisition Fund, 1977.504

1B2 MAX BECKMANN, German, 1884–1950

Self-Portrait, 1937

Oil on canvas, sight: 75¾ x 34½ in. (192.4 x 87.6 cm.)
Signed and dated lower right: "Beckmann / 3.37"
Gift of Mrs. Sheldon Ackerman and Mr. Philip Ringer, 1955.822

1B3 ALBERT BESNARD, French, 1849–1934

By the Lake, 1923

Oil on canvas, 59³/₁₆ x 46½ in. (150.3 x 118.1 cm.)
Signed lower left: "ABesnard"
A. A. Munger Collection, 1924.221

1B4 CHRISTIAN BOLTANSKI, French, b. 1944

Detective, 1972–73

408 magazine photographs in various sizes
Twentieth Century Purchase Fund, 1974.223

1B5 PIERRE BONNARD, French, 1867–1947

Red Flowers, 1923

Oil on canvas, 29½ x 19¹¹/₁₆ in. (74.9 x 50 cm.)
Signed lower right: "Bonnard"
Gift of Mrs. Clive Runnells, 1959.507

1B6 PIERRE BONNARD

La Seine à Vernon, 1930

Oil on canvas, 42½ x 42½ in. (108 x 108 cm.)
Signed lower left: "Bonnard"
Clyde M. Carr Fund, 1962.357

1B7 CONSTANTIN BRANCUSI, Rumanian/French, 1876–1957

Sketch of a Child, c. 1907–9

Oil on cardboard, 23⅞ x 11¼ in. (60.6 x 28.6 cm.)
Signed lower right: "C Brancusi"
Gift of Joseph Winterbotham, 1954.1353

1B8 SIR FRANK BRANGWYN, British, 1867–1956

Illustration for the Rubaiyat of Omar Khayyam, c. 1914

Oil on panel, 15 x 24 in. (38.1 x 61 cm.)
Signed lower left: "F B"
Gift of Mr. and Mrs. Robert D. Graff in memory of
Thomas Wood Stevens and Kenneth Sawyer Goodman,
1973.54

1B9 GEORGES BRAQUE, French, 1882–1963

Harbor in Normandy, 1909

Oil on canvas, 31¹⁵/₁₆ x 31¹¹/₁₆ in. (81.1 x 80.5 cm.)
Not signed
Samuel A. Marx Purchase Fund, 1970.98

1B10 GEORGES BRAQUE

Still Life, 1919

Oil on canvas, 19¾ x 36⁵/₁₆ in. (50.2 x 92.2 cm.)
Signed lower right: "G Braque"; signed on verso
Joseph Winterbotham Collection, 1929.764

1B11 GEORGES BRAQUE

Fruits and Guitar, 1938

Oil on canvas, 32 x 39⅜ in. (81.3 x 100 cm.)

Signed and dated lower left: "G Braque / 38
Gift of Mrs. Albert D. Lasker in memory of her husband,
Albert D. Lasker, 1959.505

1B12 GEORGES BRAQUE

The Wheatfield, 1951–52

Oil on canvas, 14³/₁₆ x 22 in. (36 x 55.9 cm.)
Signed lower left: "G Braque"
Gift of Mr. and Mrs. Leigh B. Block, 1970.1037

1C1 VICTOR BRAUNER, Rumanian, 1903–66
ROBERTO CRIPPA, Italian, 1921–72

Prelude to a Synthesis, 1959

Oil on wood with cork and metal, 78⅞ x 55⅛ in.
(200.3 x 140 cm.)
Signed, dated, and titled lower right: "R. Crippa 59 /
PRELUDİO Dİ UNA SINTESİ / VICTOR BRAUNER V. 1959"
Gift of Mr. and Mrs. Henry Markus, 1965.1175

1C2 ALBERTO BURRI, Italian, b. 1915

Bianco, 1952

Oil and collage on canvas, 22⅜ x 33¼ in. (56.8 x 84.5
cm.)
Not signed on recto; signed on verso
Gift of Dr. and Mrs. Harry O. Maryan, 1955.824

1C3 HEINRICH CAMPENDONK, German, 1889–1957

Landscape, 1917

Oil on canvas, 27 x 20 in. (68.6 x 50.8 cm.)
Signed and dated lower right: "C 17"; signed, dated,
and titled on verso
Bequest of Grant J. Pick, 1963.361

1C4 GEORGES ÉMILE CAPON, French, b. 1890

The Ball of Ebony, 1925

Oil on canvas, 36¼ x 25⅝ in. (92.1 x 65.1 cm.)
Signed and dated lower right: "CAPON / –25–"
Gift of Mr. and Mrs. Carter H. Harrison, 1936.5

1C5 GEORGES ÉMILE CAPON

La Java, 1925

Oil on canvas, 28¾ x 23¾ in. (73 x 60.3 cm.)
Signed and dated lower left: "Capon –25–"
Gift of Mr. and Mrs. Carter H. Harrison, 1937.377

1C6 GEORGES ÉMILE CAPON

The Scotch Gown, 1926

Oil on canvas, 36¼ x 23⅝ in. (92.1 x 60 cm.)
Signed lower left: "CAPON"
Gift of Mr. and Mrs. Carter H. Harrison, 1935.301

1C7 GEORGES ÉMILE CAPON

Spanish Beggar Boys, 1928

Oil on canvas, 31⅞ x 39¼ in. (81 x 99.7 cm.)
Signed, dated and inscribed upper left: "Seville 28 /
CAPON"
Gift of Mr. and Mrs. Carter H. Harrison, 1937.378

1C8 GEORGES ÉMILE CAPON

Woman with Tulips, 1928

Oil on canvas, 39⅜ x 31⅞ in. (100 x 81 cm.)
Signed lower left: "CAPON"
Gift of Mr. and Mrs. Carter H. Harrison, 1936.6

1C9 GEORGES ÉMILE CAPON

Woman Reading, 1930

Oil on canvas, 28¾ x 23⅝ in. (73 x 60 cm.)
Signed lower right: "CAPON"
Gift of Mr. and Mrs. Carter H. Harrison, 1935.302

1C10 CARLO CARRÀ, Italian, 1881–1966

Horsemen of the Apocalypse, 1908

Oil on canvas, 14³/₁₆ x 37 in. (36 x 94 cm.)
Signed and dated lower right: "C. CARRĀ [1]908";
signed and inscribed on stretcher
Gift of Mr. and Mrs. Harold X. Weinstein, 1964.1218

1C11 JULES CAVAILLÈS, French, 1901–77

Cannes, c. 1965

Oil on canvas, 31¾ x 25½ in. (80.7 x 64.8 cm.)
Signed lower right: "J. CAVAILLES"; signed and titled
on verso
Gift of Mrs. Gordon McCormick, 1971.349

1C12 MARC CHAGALL, Russian, b. 1887

Naissance, 1911

Oil on canvas, 44⅝ x 76⅞ in. (113.4 x 195.3 cm.)

Signed, dated and inscribed lower left: "M. chagall / Paris / 1911"; titled lower center: "Naissance"; signed, dated, titled, and inscribed on verso

Gift of Mr. and Mrs. Maurice E. Culberg, 1952.3

1D1 MARC CHAGALL

The Praying Jew (Rabbi of Vitebsk), 1923

Oil on canvas, 46 x 35³/₁₆ in. (116.8 x 89.4 cm.)

Signed lower right: "MARC / CHAGALL"

Joseph Winterbotham Collection, 1937.188

1D2 MARC CHAGALL

The Circus Rider, c. 1927

Oil on canvas, 9⅜ x 7⁷/₁₆ in. (23.8 x 18.9 cm.)

Signed lower right: "CHAGALL"

Gift of Mrs. Gilbert W. Chapman, 1949.516

1D3 MARC CHAGALL

White Crucifixion, 1938

Oil on canvas, 60¾ x 55 in. (154.3 x 139.7 cm.)

Signed and dated lower right: "MARC CHAGALL / 1938"

Gift of Alfred S. Alschuler, 1946.925

1D4 MARC CHAGALL

The Juggler, 1943

Oil on canvas, 43¼ x 31⅛ in. (109.9 x 79.1 cm.)

Signed, dated, and inscribed lower right: "CHAGALL / MARC 1943 / N.Y.[?]"

Gift of Mrs. Gilbert W. Chapman, 1952.1005

1D5 ÉMILIE CHARMY, French, 1878–1974

L'Estaque, c. 1910

Oil on canvas, 22⁹/₁₆ x 29⅛ in. (57.3 x 74 cm.)

Signed lower right: "E. Charmy"

Arthur Jerome Eddy Memorial Collection, 1931.518

1D6 GIORGIO DE CHIRICO, Italian, 1888–1978

The Philosopher's Conquest, 1914

Oil on canvas, sight: 49¼ x 39 in. (125.1 x 99.1 cm.)
Signed lower right: "G. de Chirico"
Joseph Winterbotham Collection, 1939.405

1D7 GIORGIO DE CHIRICO

Classical Figures, c. 1923–28

Oil on panel, 27¹¹/₁₆ x 23³/₁₆ in. (70.3 x 58.9 cm.)
Signed upper left of center: "G. de Chirico"
Gift of Joseph Winterbotham, 1954.305

1D8 GIORGIO DE CHIRICO

Neoclassical Composition, 1927 [reproduced in black and white]

Oil and pastel on canvas, sight: 56½ x 44½ in. (143.5 x 113 cm.)
Signed and dated lower left: "G. de Chirico / 1927"
Gift of Mrs. Frederic C. Bartlett, 1964.213

1D9 GIORGIO DE CHIRICO

Nude, c. 1928–29

Oil on canvas, 21¹¹/₁₆ x 18⅛ in. (55.1 x 46 cm.)
Signed upper right: "G.de Chirico"
Gift of Joseph Winterbotham, 1954.1354

1D10 LOVIS CORINTH, German, 1858–1925

Self-Portrait, 1917

Oil on canvas, 18⅛ x 14½ in. (46 x 36.8 cm.)
Signed and dated center right: "LOVIS / CORINTH /i Mai / 1917"
Mr. and Mrs. Lewis Larned Coburn Memorial, 1968.608

1D11 CHARLES COTTET, French, 1863–1925

Portrait of a Woman, c. 1900

Oil on canvas, 24 x 20⅛ in. (61 x 51.1 cm.)
Signed lower right: "Ch. Cottet"
Gift of Henry Willing, 1921.82

ROBERTO CRIPPA, see 1C1.

1D12 SALVADOR DALI, Spanish, b. 1904

Inventions of the Monsters, 1937

Oil on canvas, 20¼ x 30¾ in. (51.4 x 78.1 cm.)
Not signed on recto; signed and dated on verso
Joseph Winterbotham Collection, 1943.798

1E1 HANNE DARBOVEN, German, b. 1941

Seven Panels and Index, 1973

Pencil on paper, sight, each panel: 68½ x 68½ in. (174 x 174 cm.); sight, index: 41 x 68½ in. (104.1 x 174 cm.)
Not signed
Barbara Neff Smith Memorial Fund, 1977.600

1E2 ROBERT DELAUNAY, French, 1885–1941

Champs de Mars, The Red Tower, 1911

Oil on canvas, sight: 63¼ x 50⅝ in. (160.7 x 128.6 cm.)
Signed and dated lower right: "r.d. 1911"; signed, dated, titled, and inscribed on verso
Joseph Winterbotham Collection, 1959.1

1E3 PAUL DELVAUX, Belgian, b. 1897

The Village of the Mermaids, 1942

Oil on panel, 41¹/₁₆ x 48⅞ in. (104.3 x 124.1 cm.)
Signed and dated lower right: "P. DELVAUX / 4–42"; titled on verso
Gift of Mr. and Mrs. Maurice E. Culberg, 1951.73

1E4 ANDRÉ DERAIN, French, 1880–1954

Forest at Martigues, c. 1908–9

Oil on canvas, 32 x 39½ in. (81.3 x 100.3 cm.)
Not signed
Arthur Jerome Eddy Memorial Collection, 1931.506

1E5 ANDRÉ DERAIN

Cagnes, 1910

Oil on canvas, 21⁹/₁₆ x 30¹/₁₆ in. (54.8 x 76.4 cm.)
Not signed
Worcester Sketch Fund, 1960.777

1E6 ANDRÉ DERAIN

Last Supper, 1911

Oil on canvas, 89¼ x 113½ in. (226.7 x 288.3 cm.)
Signed lower right: "a derain"
Gift of Mrs. Frank R. Lillie, 1946.339

1E7 ANDRÉ DERAIN

Landscape, c. 1920–25

Oil on panel, 23⁷/₁₆ x 28¹¹/₁₆ in. (59.5 x 72.9 cm.)
Signed lower right: "a derain"
Helen Birch Bartlett Memorial Collection, 1926.190

1E8 ANDRÉ DERAIN

The Fountain, early 1920s

Oil on panel, 10¾ x 13⅝ in. (27.3 x 34.6 cm.)
Signed lower right: "a derain"
Helen Birch Bartlett Memorial Collection, 1926.350

1E9 ANDRÉ DERAIN

Grapes, early 1920s

Oil on canvas, 9¾ x 17⅜ in. (24.8 x 44.1 cm.)
Signed lower right: "a derain"
Helen Birch Bartlett Memorial Collection, 1926.191

1E10 ANDRÉ DERAIN

Ballet Dancer, late 1920s

Oil on canvas, 17¹⁵/₁₆ x 14⁹/₁₆ in. (45.6 x 37 cm.)
Signed lower right: "a derain"
Charles H. and Mary F. S. Worcester Collection, 1947.66

1E11 ANDRÉ DERAIN

Landscape in Provence, 1931

Oil on panel, 14⅞ x 21⅝ in. (37.8 x 55 cm.)
Signed lower right: "a derain"
Charles H. and Mary F. S. Worcester Collection, 1947.67

1E12 PAUL DESSAU, British, b. 1909

Self-Portrait, 1940

Oil on canvas, 24 x 19⅛ in. (61 x 48.6 cm.)
Signed and dated lower left: "PAUL DESSAU '40"; inscribed across top: "The Tired Fireman—After Surrey Docks September 1940"
Gift of English Speaking Union, 1942.309

1F1 THEO VAN DOESBURG (C. E. M. Küpper), Dutch, 1883–1931

Counter-Composition VIII, 1924

Oil on canvas, 39¾ x 39¾ in. (101 x 101 cm.)

Not signed on recto; signed, dated, titled, and inscribed on verso

Gift of Peggy Guggenheim, 1949.216

1F2 JEAN DUBUFFET, French, b. 1901

Jules Supervielle grand portrait mythe or *Supervielle grand portrait bannière*, 1947

Oil and mixed media on canvas, 51¼ x 38¼ in. (130.2 x 97.2 cm.)

Not signed

Gift of Mr. and Mrs. Maurice E. Culberg, 1950.1367

1F3 JEAN DUBUFFET

Texturologie VIII (dorée) (Relevé de terrain), 1957

Oil on canvas, 45 x 57⅝ in. (114.3 x 146.4 cm.)

Signed and dated upper left: "J. Dubuffet 57"; signed, dated, and titled on verso

Gift of the artist in honor of Maurice E. Culberg, 1967.678

1F4 JEAN DUBUFFET

Texturologie LX (Vacance au sol), 1958

Oil on canvas, 44⅞ x 57⅝ in. (114 x 146.4 cm.)

Signed and dated lower left: "J. Dubuffet / 58"; signed, dated, and titled on verso

Gift of the artist in honor of Maurice E. Culberg, 1967.727

1F5 JEAN DUBUFFET

Genuflexion of the Bishop, 1963

Oil on canvas, sight: 85¾ x 117½ in. (217.8 x 298.5 cm.)

Signed and dated lower left: "J. Dubuffet 63"; signed, dated, and titled on verso

Joseph Winterbotham Collection, 1964.1087

1F6 JEAN DUBUFFET

La Chasse au trésor, 1978

Acrylic and oil collage on canvas, 55⅛ x 40¼ in. (140 x 102.2 cm.)

Signed and dated lower right: "J.D. 78"
Neison and Bette Harris Acquisition Fund, 1978.416

1F7　MARCEL DUCHAMP, French/American, 1887–1968

Nude Seated in a Bathtub, 1910

Oil on canvas, 36¼ x 28¾ in. (92.1 x 73 cm.)
Signed and dated lower right: "Duchamp / –10";
signed and dated on stretcher
Gift of Mrs. Marcel Duchamp, 1974.227

1F8　CHARLES GEORGES DUFRESNE, French, 1876–1938

La Toilette de la mariée (Jungle Symphony), 1921

Oil on canvas, 39⅝ x 32 in. (100.6 x 81.3 cm.)
Signed lower left: "dufresne"
Gift of Joseph Winterbotham, 1954.310

1F9　CHARLES GEORGES DUFRESNE

Still Life with Flowers, 1923

Oil on canvas, 25½ x 21¼ in. (64.8 x 54 cm.)
Signed lower center: "dufresne"
Gift of Joseph Winterbotham, 1954.309

1F10　RAOUL DUFY, French, 1877–1953

Open Window, Nice, 1928

Oil on canvas, 25⅝ x 21⅛ in. (65.1 x 53.7 cm.)
Signed lower right: "Raoul Dufy"
Joseph Winterbotham Collection, 1937.166

1F11　RAOUL DUFY

Villerville, c. 1928

Oil on canvas, 29¾ x 37⁵/₁₆ in. (75.6 x 94.8 cm.)
Signed lower left: "Raoul Dufy"
Joseph Winterbotham Collection, 1931.708

1F12　RAOUL DUFY

The Marne at Nogent, 1935

Oil on canvas, 51³/₁₆ x 64 in. (130 x 162.6 cm.)
Signed and dated lower right: "Raoul Dufy 1935"
Gift of Arthur Keating, 1951.315

1G1　ANDRÉ DUNOYER DE SEGONZAC, French, 1884–1974

Pasture (Scène de pâturage), 1912

Oil on canvas, 28⅞ x 36 in. (73.3 x 91.4 cm.)
Signed lower left: "A. D de Segonzac"
Arthur Jerome Eddy Memorial Collection, 1931.516

1G2 ANDRÉ DUNOYER DE SEGONZAC

Still Life, early 1920s

Oil on panel, 21¹¹/₁₆ x 17⅞ in. (55.1 x 45.4 cm.)
Signed lower right: "A. Dunoyer / de Segonzac"
Helen Birch Bartlett Memorial Collection, 1926.194

1G3 ANDRÉ DUNOYER DE SEGONZAC

Summer Garden (The Hat with the Scottish Ribbon), 1926

Oil on canvas, 19⅞ x 43⅜ in. (50.5 x 110.2 cm.)
Signed lower left: "A. Dunoyer de Segonzac"
Joseph Winterbotham Collection, 1929.184

1G4 W. RUSSELL FLINT, Scottish, 1880–1969

Gypsy Women at Les Stes Maries, Provence, 1944

Oil on canvas, 22½ x 29 in. (57.2 x 73.7 cm.)
Signed lower left: "W. RUSSELL FLINT"; signed, titled, and inscribed on stretcher
Gift of Mrs. Moe Goldstein, 1974.407

1G5 JEAN-LOUIS FORAIN, French, 1852–1931

Maternity, c. 1904–5

Oil on canvas, 25⅞ x 32¹/₁₆ in. (65.7 x 81.4 cm.)
Signed lower right: "forain"
Charles H. and Mary F. S. Worcester Collection, 1929.920

1G6 JEAN-LOUIS FORAIN

Sentenced for Life, c. 1910

Oil on canvas, 25¾ x 31⅞ in. (65.4 x 81 cm.)
Signed lower right: "forain"
Joseph Winterbotham Collection, 1923.6

1G7 TSUGOUHARU FOUJITA, Japanese, 1886–1968

Portrait of Mrs. E. C. Chadbourne, 1922

Tempera on canvas, 35⅛ x 57½ in. (89.2 x 146.1 cm.)
Signed, dated and inscribed lower left: "[Japanese characters] / T. Foujita / Paris / 1922"; signed, dated, and inscribed on stretcher
Gift of Emily Crane Chadbourne, 1952.997

1G8　Paul Gauguin, French, 1848–1903

Tahitian Woman with Children, 1901

Oil on canvas, 38¼ x 29¼ in. (97.2 x 74.3 cm.)
Signed and dated upper left: "Paul Gauguin / 1901"
Helen Birch Bartlett Memorial Collection, 1927.460

1G9　Robert Genin, Russian, 1884–1943

Thirst, 1913

Oil on canvas, 39³/₁₆ x 31½ in. (99.5 x 80 cm.)
Signed and dated lower right: "RGenin 13"
Arthur Jerome Eddy Memorial Collection, 1931.520

1G10　Juan Genovés, Spanish, b. 1930

Angulo 18°, 1967

Acrylic and oil on canvas, 55⅛ x 59⅛ in. (140 x 150.2
cm.)
Signed and dated lower right: "genovés / 67"; signed,
dated, titled, and inscribed on verso
Kate S. Maremont Foundation Restricted Gift, 1967.679

1G11　Alberto Giacometti, Swiss, 1901–66

Isaku Yanaihara, 1956

Oil on canvas, 31¹⁵/₁₆ x 25½ in. (81.1 x 64.8 cm.)
Signed and dated lower right: "Alberto Giacometti
1956"
Gift of Silvain and Arma Wyler, 1959.11

1G12　Alberto Giacometti

Caroline, 1962

Oil on canvas, 51 x 38⅛ in. (129.5 x 96.8 cm.)
Signed and dated lower right: "Alberto Giacometti /
1962"
Gift through the Mary and Leigh Block Fund for Acqui-
sitions in memory of Mrs. Loula Lasker, 1964.1086

2A1　Gilbert & George (Gilbert Proesch and George
Passmore), British, b. 1943 and 1942

The Alcoholic, 1978

16 black-and-white photographs, each 23¾ x 19¾ in.
(60.3 x 50.2 cm.)

Signed, dated, and titled lower right: "THE ALCOHOLIC / George and Gilbert / 1978"
Twentieth Century Purchase Fund, 1978.57

2A2 EDOUARD GOERG, French, 1893–1969

The Stroke of Lightning, 1921–27

Oil on canvas, 28¾ x 36⅜ in. (73 x 92.4 cm.)
Signed lower center: "E. GOERG"; dated and titled on verso
Gift of Mr. and Mrs. Carter H. Harrison, 1936.8

2A3 EDOUARD GOERG

The Epicure, 1923

Oil on canvas, 39⅜ x 32 in. (100 x 81.3 cm.)
Signed and dated lower right: "ED. GOERG. / 1923"; signed, dated, and titled on verso
Gift of the Joseph Winterbotham Collection, 1929.765

2A4 EDOUARD GOERG

Table d'hote, 1924–27

Oil on canvas, 36⁵⁄₁₆ x 28⅞ in. (92.2 x 73.3 cm.)
Signed lower center: "E. GOERG"; signed, dated, and titled on verso
Gift of Mr. and Mrs. Carter H. Harrison, 1935.304

2A5 EDOUARD GOERG

The Hunters' Car, mid-1920s

Oil on canvas, sight: 23¹⁄₁₆ x 31⅜ in. (58.6 x 79.7 cm.)
Signed lower left: "goerg"; signed and titled on verso
Gift of Mr. and Mrs. Carter H. Harrison, 1937.379

2A6 NATHALIE GONTCHAROVA, Russian/French, 1881–1962

Spanish Dancer, c. 1916

Oil on canvas, 79 x 35 in. (200.7 x 88.9 cm.)
Signed lower right: "N. Gontcharova"; signed, titled, and inscribed on verso
Gift of Mrs. Patrick C. Hill in memory of her mother, Rue Winterbotham Carpenter, 1971.777

2A7 JUAN GRIS (JOSÉ VICTORIANO GONZÁLEZ), Spanish, 1887–1927

Portrait of Picasso, 1912

Oil on canvas, 29³/₁₆ x 36⁵/₈ in. (74.1 x 93 cm.)
Signed and inscribed lower right: "Hommage à Pablo Picasso / Juan Gris"
Gift of Leigh B. Block, 1958.525

2A8 JUAN GRIS

A Table at a Café (Abstraction in Gray), 1912

Oil on canvas, 18¼ x 15⅛ in. (46.4 x 38.4 cm.)
Signed lower left: "Juan Gris"
Bequest of Kate L. Brewster, 1950.122

2A9 JUAN GRIS

Abstraction (Still Life with Guitar), 1913

Oil on canvas, 36¼ x 23¹³/₁₆ in. (92.1 x 60.5 cm.)
Not signed on recto; signed and dated on verso
Charles H. and Mary F. S. Worcester Fund, 1961.36

2A10 JUAN GRIS

The Checkboard (Le Damier), 1915

Oil on canvas, 36¼ x 28¾ in. (92.1 x 73 cm.)
Signed and dated lower left: "Juan Gris / 9–1915"
Gift of Mrs. Leigh B. Block with contribution from the Ada Turnbull Hertle Fund, 1956.16

2A11 JUAN GRIS

Guitar and Compote, 1921

Oil on canvas, 15 x 24⅛ in. (38.1 x 61.3 cm.)
Signed and dated lower left: "Juan Gris / 2–21"
Mildred Sexton Trust, 1976.427

2A12 JEAN-BAPTISTE ARMAND GUILLAUMIN, French, 1841–1927

The Water Mill of Pont Maupuit (Crozant), c. 1900

Oil on canvas, 25⁵/₁₆ x 31⁹/₁₆ in. (64.3 x 80.2 cm.)
Signed lower right: "Guillaumin"
Mr. and Mrs. Martin A. Ryerson Collection, 1933.1123

2B1 JEAN HÉLION, French, b. 1904

Twin Figures, 1938

Oil on canvas, 52 x 69 in. (132.1 x 175.3 cm.)
Not signed on recto; signed and dated on verso
Gift of Peggy Guggenheim, 1957.14

2B2 AUGUSTE HERBIN, French, 1882–1960

House and Flowering Cherry Trees, Hamburg, c. 1910–12
 Oil on canvas, 23⅜ x 28⅞ in. (59.4 x 73.3 cm.)
 Signed lower right: "Herbin"
Arthur Jerome Eddy Memorial Collection, 1931.507

2B3 FERDINAND HODLER, Swiss, 1853–1918

James Vibert, Sculptor, 1907
 Oil on canvas, 25¾ x 26⅛ in. (65.4 x 66.4 cm.)
 Signed and dated lower right: "1907 F. Hodler"
Helen Birch Bartlett Memorial Collection, 1926.212

2B4 FERDINAND HODLER

The Grand Muveran, c. 1912
 Oil on canvas, 27⅞ x 37¾ in. (70.8 x 95.9 cm.)
 Signed lower right: "F. Hodler"; inscribed on
stretcher
Helen Birch Bartlett Memorial Collection, 1926.211

2B5 FERDINAND HODLER

Head of a Soldier, 1917
 Oil on canvas, 18⅜ x 17¹/₁₆ in. (46.7 x 43.3 cm.)
 Signed lower right: "F. Hodler"
Helen Birch Bartlett Memorial Collection, 1926.213

2B6 CARL HOFER, German, 1878–1955

Girls Throwing Flowers, 1934
 Oil on canvas, 48⅝ x 38¹³/₁₆ in. (123.5 x 98.6 cm.)
Signed and dated lower left: "CH 34"
Joseph Winterbotham Collection, 1936.221

2B7 MARCEL JANCO, Rumanian/Israeli, b. 1895

Composition with Red Arrow, 1918
 Casein and plaster on burlap, mounted on masonite,
19¾ x 26¼ in. (50.2 x 66.7 cm.)
 Signed and dated lower left of center: "M. Janco '18";
signed on verso; inscribed on frame
Gift of Mr. and Mrs. Henry Markus, 1963.374

2B8 ALEXEI JAWLENSKY, Russian, 1864–1941

Girl with the Green Face, 1910

Oil on composition board, 20^{15}/$_{16}$ x 19^{9}/$_{16}$ in. (53.2 x 49.7 cm.)

Signed upper left: "a. jawlensky"; oil sketch on verso

Gift of Mr. and Mrs. Earle Ludgin in memory of John V. McCarthy, 1953.336

2B9 ALEXEI JAWLENSKY

Mittlere Kopfe Nr. 1 (Andrej), 1917

Oil on paper, mounted on panel, 15^{5}/$_{8}$ x 12^{1}/$_{8}$ in. (39.7 x 30.8 cm.)

Not signed

Bequest of Maxine Kunstadter, 1978.401

CHARLES ÉDOUARD JEANNERET (LE CORBUSIER), see 2D8

2B10 AUGUSTUS EDWIN JOHN, British, 1878–1961

The Rogue (L'Espiègle), 1923

Oil on canvas, 30 x 25 in. (76.2 x 63.5 cm.)

Signed and dated lower right: "John / 1923"

Charles H. and Mary F. S. Worcester Collection, 1925.728

2B11 AUGUSTUS EDWIN JOHN

Study of a Child, 1923

Oil on panel, 19^{1}/$_{2}$ x 10^{7}/$_{8}$ in. (49.5 x 27.6 cm.)

Signed twice, center right: "John / John"

Charles H. and Mary F. S. Worcester Collection, 1935.444

2B12 WASSILY KANDINSKY, Russian, 1866–1944

Kallmünz, 1904

Oil on cardboard, 6^{11}/$_{16}$ x 10^{3}/$_{16}$ in. (17 x 25.9 cm.)

Signed lower left: "KANDINSKY"

Bequest of Grant J. Pick, 1963.363

2C1 WASSILY KANDINSKY

Troika, 1911

Oil on cardboard, sight: 28^{3}/$_{4}$ x 39^{5}/$_{8}$ in. (73 x 100.6 cm.)

Signed lower left: "KANDINSKY"

Arthur Jerome Eddy Memorial Collection, 1931.509

2C2 WASSILY KANDINSKY

Landscape with Two Poplars, 1912

Oil on canvas, sight: 30^{5}/$_{8}$ x 39^{3}/$_{8}$ in. (77.8 x 100 cm.)

Signed lower right: "KANDINSKY"; signed, titled, and inscribed on stretcher
Arthur Jerome Eddy Memorial Collection, 1931.508

2C3 WASSILY KANDINSKY

Improvisation No. 30, 1913

Oil on canvas, sight: 43 x 43¼ in. (109.2 x 109.9 cm.)
Signed and dated lower left: "KANDINSKY i9i3"; signed, titled and inscribed on stretcher
Arthur Jerome Eddy Memorial Collection, 1931.511

2C4 WASSILY KANDINSKY

Improvisation with Green Center (No. 176), 1913

Oil on canvas, sight: 42⅞ x 46⅝ in. (108.9 x 118.4 cm.)
Signed and dated lower right: "KANDINSKY i9i3"; inscribed on stretcher
Arthur Jerome Eddy Memorial Collection, 1931.510

2C5 GEORGE KARS, Czechoslovakian, 1882–1945

Oriental Woman with Earthen Jar, 1930

Oil on canvas, 39⅝ x 32⅛ in. (100.7 x 81.6 cm.)
Signed and dated lower left: "Kars / 30"
Gift of Mr. and Mrs. Carter H. Harrison, 1935.308

2C6 GEORGE KARS

Woman Viewed from the Back, 1930

Oil on canvas, 25⅝ x 21⅜ in. (65.1 x 54.3 cm.)
Signed and dated lower left: "Kars / 30"
Gift of Mr. and Mrs. Carter H. Harrison, 1937.382

2C7 YASUO KAZUKI, Japanese, 1911–74

Two Goats, c. 1958–59

Oil on canvas, 16 x 23⅞ in. (40.6 x 60.6 cm.)
Signed lower left: "Y. Kazuki"; signed on verso; titled on stretcher
Gift of James Brown IV, 1964.241

2C8 ERNST LUDWIG KIRCHNER, German, 1880–1938

Mountain Valley with Huts, c. 1917–18

Oil on canvas, sight: 38⅜ x 46¾ in. (97.5 x 118.8 cm.)
Signed lower right: "E. L. Kirchner"
Wilson L. Mead Fund, 1961.1114

2C9 PAUL KLEE, German, 1879–1940

School House, 1920

Oil on cardboard, sight: 14½ x 11½ in. (36.8 x 29.2 cm.)

Signed, dated, and numbered, lower left of center: "Klee 1920.23"; signed, dated, titled, and numbered on verso

Gift of Mr. and Mrs. Leigh B. Block, 1969.811

2C10 PAUL KLEE

Stakim, 1931

Tempera on burlap on plasterboard, 8½ x 13 in. (21.6 x 33 cm.)

Signed upper left: "Klee"

Gift of Mrs. Gilbert W. Chapman, 1948.560

2C11 PAUL KLEE

Women Harvesting, c. 1937

Pastel on canvas on burlap, 20 x 21⅜ in. (50.8 x 54.3 cm.)

Signed upper left of center: "Kl"

Gift of Mrs. Morton G. Schamberg, 1959.18

2C12 PAUL KLEE

Harmonisierte Gegend, 1938

Oil on burlap, sight: 15¼ x 18⅜ in. (38.7 x 46.7 cm.)

Dated and numbered on mount, lower left: "1938 T5"; titled on mount, lower right: "harmonisierte Gegend"

Gift from the Estate of Alexander M. Bing, 1959.510

2D1 PAUL KLEE

Herzog Leiter nicht allein, 1938

Oil on paper, sight: 13⅝ x 19¼ in. (34.6 x 49 cm.)

Signed upper left: "Klee"; dated and numbered on mount, lower left: "1938 N4"; titled on mount lower right: "Herzog Leiter nicht allein"

Cyrus McCormick Fund, 1951.255

2D2 PAUL KLEE

Dancing Girl, 1940

Oil on cloth, sight: 20½ x 20½ in. (52.1 x 52.1 cm.)

Signed lower right: "P K"
Gift of George B. Young, 1959.172

2D3 OSKAR KOKOSCHKA, Austrian/British, 1886–1980

Portrait of Ebenstein, 1908

Oil on canvas, 40^1/$_{16}$ x 31^{15}/$_{16}$ in. (101.8 x 81.1 cm.)
Signed lower right: "O K"
Joseph Winterbotham Collection, 1956.364

2D4 OSKAR KOKOSCHKA

Elbe River near Dresden, 1919

Oil on canvas, 32^1/$_{16}$ x 44^3/$_{16}$ in. (81.4 x 112.2 cm.)
Signed lower right: "O K"
Joseph Winterbotham Collection, 1939.2244

2D5 PER KROHG, Norwegian, 1889–1965

The Ambassadress—A Nouveau Riche, 1929

Oil on canvas, 45¾ x 34^{15}/$_{16}$ in. (116.2 x 88.7 cm.)
Signed lower right: "Per / Krohg"
Gift of Mr. and Mrs. Carter H. Harrison, 1936.9

2D6 PER KROHG

Conversation, c. 1930

Oil on canvas, 39⅜ x 31^{15}/$_{16}$ in. (100 x 81.1 cm.)
Signed lower left: "Per Krohg"
Gift of Mr. and Mrs. Carter H. Harrison, 1935.305

2D7 ELIE LASCAUX, French, 1888–1969

Chartres Cathedral, 1930

Oil on canvas, 31^{15}/$_{16}$ x 39⅜ in. (81.1 x 100 cm.)
Signed lower right: "LASCAUX"; signed on stretcher;
titled on verso
Gift of Joseph Winterbotham, 1954.1358

2D8 LE CORBUSIER (CHARLES ÉDOUARD JEANNERET), Swiss/
French, 1887–1965

Abstract Composition, 1927

Oil on canvas, 16⅛ x 10¾ in. (41 x 27.3 cm.)
Not signed on recto; signed, dated and inscribed on
verso
Bequest from the Estate of Hedwig B. Schniewind,
1963.865

2D9 FERNAND LÉGER, French, 1881–1955

Follow the Arrow (Study for The Level Crossing), 1919
 Oil on canvas, 21⁵/₁₆ x 25⅞ in. (54.1 x 65.7 cm.)
 Signed lower right: "F.LEGER"; signed, dated, titled,
and inscribed on verso
Joseph Winterbotham Collection, Gift of Mrs. Patrick
Hill in memory of Rue Winterbotham Carpenter,
1953.341

2D10 FERNAND LÉGER

The Red Table, 1920
 Oil on canvas, 21⁵/₁₆ x 25⅝ in. (54.1 x 65.1 cm.)
 Signed and dated lower right: "F.LÈGE / R / 20"; signed,
dated, and titled on verso
Bequest of Kate L. Brewster, 1948.557

2D11 FERNAND LÉGER

Composition in Blue, 1921–27
 Oil on canvas, 51⅜ x 38¼ in. (130.5 x 97.2 cm.)
 Signed and dated lower right: "F.LÈGER—21.27";
signed, dated, and titled on verso
Gift of Charles H. and Mary F. S. Worcester, 1937.461

2D12 FERNAND LÉGER

Nature Morte tricolore, 1928
 Oil on canvas, 28⅞ x 36¼ in. (73.3 x 92.1 cm.)
 Signed and dated lower right: "F.LÈGER.28"; signed,
dated, and titled on verso
Gift of Mr. and Mrs. Leigh B. Block, 1953.468

2E1 FERNAND LÉGER

Divers on a Yellow Background, 1941
 Oil on canvas, sight: 73½ x 85¾ in. (186.7 x 217.8 cm.)
 Signed and dated lower right: "41 / F.LEGER"; signed,
dated, and titled on verso
Gift of Mr. and Maurice E. Culberg, 1953.176

2E2 HENRI-EUGÈNE LE SIDANER, French, 1862–1939

Seine and Pont Royal, c. 1905–10
 Oil on canvas, 33¼ x 47 in. (84.5 x 119.4 cm.)
 Signed lower right: "LE SIDANER"
Mr. and Mrs. Martin A. Ryerson Collection, 1933.1131

2E3 ANDRÉ LHOTE, French, 1885–1962

Le Port de Bordeaux, 1914

Oil on pulpboard, 26⅞ x 31⅞ in. (68.3 x 81 cm.)
Signed lower left: "A.LHOTE"
Gift of Sheila and Alvin Ukman, 1978.418

2E4 ANDRÉ LHOTE

The Ladies of Avignon, c. 1923

Oil on canvas, 43⁹/₁₆ x 33⅜ in. (110.7 x 84.8 cm.)
Signed lower right: "A.LHOTE"; signed and titled on
verso
Helen Birch Bartlett Memorial Collection, 1926.215

2E5 ANDRÉ LHOTE

Madame Lhote at the Piano, 1927

Oil on canvas, 35¼ x 23½ in. (89.5 x 59.7 cm.)
Signed lower right: "A.LHOTE"
Gift of Mr. and Mrs. Carter H. Harrison, 1935.306

2E6 ANDRÉ LHOTE

Portrait of a Lady, 1927

Oil on canvas, 36¼ x 28¾ in. (92.1 x 73 cm.)
Signed lower right: "A.LHOTE"
Gift of Mr. and Mrs. Carter H. Harrison, 1937.383

2E7 ANDRÉ LHOTE

Old Marseilles Harbor, 1930

Oil on canvas, 23⅝ x 36⅜ in. (60 x 92.4 cm.)
Signed and dated upper left: "A.LHOTE.30"
Gift of Mr. and Mrs. Carter H. Harrison, 1937.384

2E8 ANDRÉ LHOTE

Sailor and Woman from Martinique, 1930

Oil on canvas, 36⅜ x 28⅞ in. (92.4 x 73.3 cm.)
Signed and dated lower right: "A.LHOTE.30"
Gift of Mr. and Mrs. Carter H. Harrison, 1936.10

2E9 RENÉ MAGRITTE, Belgian, 1898–1967

Time Transfixed, 1938

Oil on canvas, 57⅞ x 38⅞ in. (147 x 98.7 cm.)

Signed lower right: "Magritte"; signed, dated, titled, and inscribed on verso
Joseph Winterbotham Collection, 1970.426

2E10　MANÉ-KATZ, Russian, 1894–1962

Flowers of Sharon, 1950s

Oil on canvas, 34⅛ x 27¼ in. (86.7 x 69.2 cm.)
Signed lower right: "Mané-Katz"
Gift of Mr. and Mrs. Herman Spertus, 1957.163

2E11　FRANZ MARC, German, 1880–1916

The Bewitched Mill, 1913

Oil on canvas, 51¼ x 35⅞ in. (130.2 x 91.1 cm.)
Signed lower left: "M."
Arthur Jerome Eddy Memorial Collection, 1931.522

2E12　JEAN HIPPOLYTE MARCHAND, French, 1883–1940

The Hill near Cagnes, c. 1920

Oil on canvas, 21⅜ x 25½ in. (54.3 x 64.8 cm.)
Signed lower left: "JH MARCHand"
Mr. and Mrs. Martin A. Ryerson Collection, 1933.1142

2F1　LOUIS MARCOUSSIS, Polish/French, 1883–1941

La Mominette, 1912

Oil on canvas, 9½ x 13 in. (24.1 x 33 cm.)
Signed lower right: "LM"; signed, titled, and inscribed on verso
Bequest of Maxine Kunstadter, 1978.402

2F2　PIERRE-ALBERT MARQUET, French, 1875–1947

Pont St Michel, Paris, c. 1910

Oil on canvas, 13 x 16⅛ in. (33 x 41 cm.)
Signed lower left: "marquet"
Mr. and Mrs. Martin A. Ryerson Collection, 1933.1145

2F3　PHILLIP MARTIN, British, b. 1927

Metro, 1952

Oil on paper, mounted on canvas and paper, over masonite, 44⅝ x 81½ in. (113.4 x 207 cm.)
Signed and dated lower left of center: "MARTIN 5/52"; inscribed lower left: "'AFFICHE de la Metro'"
Gift of Theodore S. Gary, 1955.823

2F4 GEORGES MATHIEU, French, b. 1921

Matité, 1951

Oil on canvas, 51¼ x 63⅞ in. (130.2 x 162.2 cm.)

Signed and dated upper right: "Mathieu 51"; titled on verso

Gift of Mr. and Mrs. Maurice E. Culberg, 1952.998

2F5 GEORGES MATHIEU

Fourth Avenue, 1957

Oil on canvas, 60 x 60 in. (152.4 x 152.4 cm.)

Signed, dated, and inscribed lower right: "Mathieu / New York 57 / Oct 9th"

Mary and Leigh Block Fund for Acquisitions, 1961.332

2F6 HENRI MATISSE, French, 1869–1954

Flowers, c. 1906

Oil on canvas, 7⅝ x 9⅝ in. (19.4 x 24.5 cm.)

Signed lower right: "Henri-Matisse"

Gift of Emily Crane Chadbourne, 1953.5

2F7 HENRI MATISSE

Still Life with Geranium Plant and Fruit, 1906

Oil on canvas, 39⅞ x 32½ in. (101.3 x 82.6 cm.)

Signed lower left: "Henri-Matisse"

Joseph Winterbotham Collection, 1932.1342

2F8 HENRI MATISSE

Apples, 1916

Oil on canvas, 46 x 35³/₁₆ in. (116.8 x 89.4 cm.)

Signed lower right: "Henri-Matisse"

Gift of Florene May Schoenborn and Samuel A. Marx, 1948.563

2F9 HENRI MATISSE

Bathers by a River, c. 1916–17

Oil on canvas, sight: 102¼ x 153½ in. (259.7 x 389.9 cm.)

Signed lower left: "Henri-Matisse"

Charles H. and Mary F. S. Worcester Collection, 1953.158

2F10 HENRI MATISSE

The Green Sash, 1919

Oil on canvas, 19⁵/₁₆ x 17¹/₁₆ in. (49.1 x 43.3 cm.)
Signed lower right: "Henri-Matisse"
Charles H. and Mary F. S. Worcester Collection, 1947.91

2F11 HENRI MATISSE

Interior at Nice, 1921

Oil on canvas, 52 x 35 in. (132.1 x 88.9 cm.)
Signed lower right: "Henri-Matisse"
Gift of Mrs. Gilbert W. Chapman, 1956.339

2F12 HENRI MATISSE

Woman before an Aquarium, 1921–23

Oil on canvas, 31¾ x 39⅜ in. (80.7 x 100 cm.)
Signed lower right: "Henri-Matisse"
Helen Birch Bartlett Memorial Collection, 1926.220

2G1 HENRI MATISSE

Woman on Rose Divan, 1921

Oil on canvas, 15⅛ x 18¼ in. (38.4 x 46.4 cm.)
Signed lower right: "Henri-Matisse"
Helen Birch Bartlett Memorial Collection, 1926.219

2G2 LUDWIG MEIDNER, German, 1884–1966

Portrait of Max Hermann-Neisse, 1913

Oil on canvas, 35⅛ x 29½ in. (89.2 x 74.9 cm.)
Signed and dated upper left: "L Meidner / Jan[?] 1913"
Gift of Mr. and Mrs. Harold Weinstein, 1959.215

2G3 JEAN METZINGER, French, 1883–1956

Landscape, 1912

Oil on canvas, 23⁵/₁₆ x 28¾ in. (59.2 x 73 cm.)
Signed lower left: "Metzinger"; signed and titled on verso
Gift of Mrs. Sigmund Kunstadter in memory of Sigmund Kunstadter, 1977.505

2G4 JEAN METZINGER

Woman with Fan, 1913

Oil on canvas, 36⅝ x 25¾ in. (93 x 65.4 cm.)
Signed lower left: "Metzinger"
Gift of Mr. and Mrs. Sigmund Kunstadter, 1959.10

2G5 JEAN METZINGER

Still Life, 1918

Oil on canvas, 28¹³/₁₆ x 21½ in. (73.2 x 54.6 cm.)
Signed lower right: "Metzinger"; signed, dated, and titled on verso
Gift of Mr. and Mrs. Harry L. Winston, 1954.1312

2G6 MANOLO MILLARES, Spanish, 1926–72

Cuadro 62, 1959

Oil on burlap, 51⁹/₁₆ x 63¾ in. (131 x 162 cm.)
Signed lower center: "MILLARES"; signed, dated, and titled on stretcher
Gift of Mr. and Mrs. Edwin E. Hokin, 1964.1131

2G7 JOAN MIRÓ, Spanish, b. 1893

Portrait of a Woman (Juanita Obrador), 1918

Oil on canvas, 27⅜ x 24⅜ in. (69.5 x 62 cm.)
Signed and dated lower left: "Miró / 1918"
Joseph Winterbotham Collection, 1957.78

2G8 JOAN MIRÓ

Personages with Star, 1933

Oil on canvas, 78 x 97 in. (198.1 x 246.4 cm.)
Not signed
Gift of Mr. and Mrs. Maurice E. Culberg, 1952.512

2G9 JOAN MIRÓ

Homme, femmes et taureau, 1935

Oil on sandpaper, mounted on canvas, surrounded by feathers, sight: 43½ x 39 in. (110.5 x 99.1 cm.)
Signed upper center of sandpaper: "Miró"; signed, dated, and titled on verso
Gift of Mr. and Mrs. Harold X. Weinstein, 1960.908

2G10 JOAN MIRÓ

Painting, 1936

Oil on masonite, 30⁹/₁₆ x 42³/₁₆ in. (77.6 x 107.2 cm.)

Signed lower right of center: "Miró"; signed, dated, and titled on verso
Gift of Florene May Schoenborn and Samuel A. Marx, 1950.1518

2G11 PAULA MODERSOHN-BECKER, German, 1876–1907

Still Life, c. 1900

Oil on cardboard, sight: 14⅛ x 11 in. (35.9 x 27.9 cm.)
Not signed
Worcester Sketch Fund, 1962.317

2G12 AMEDEO MODIGLIANI, Italian, 1884–1920

Madam Pompadour, 1915

Oil on canvas, 24¹/₁₆ x 19¾ in. (61.1 x 50.2 cm.)
Signed lower right: "modigliani"; dated and inscribed left center: "Madam / Pompadour / 1915"
Joseph Winterbotham Collection, 1938.217

3A1 AMEDEO MODIGLIANI

Jacques Lipchitz and His Wife, 1916

Oil on canvas, 31¾ x 21¼ in. (80.7 x 54 cm.)
Signed upper right: "modigliani"; inscribed upper center: "LIPCHITZ"
Helen Birch Bartlett Memorial Collection, 1926.221

3A2 AMEDEO MODIGLIANI

Portrait of Mme Zborowski, 1917

Oil on canvas, 31¹³/₁₆ x 17¹⁵/₁₆ in. (80.8 x 45.6 cm.)
Signed upper right: "modigliani"
Gift of Mr. and Mrs. Edwin E. Hokin in memory of Loraine E. Hokin, 1955.1534

3A3 AMEDEO MODIGLIANI

Woman with Necklace, 1917

Oil on canvas, 36⁵/₁₆ x 23¾ in. (92.2 x 60.3 cm.)
Signed upper right: "modigliani"
Charles H. and Mary F. S. Worcester Collection, 1947.93

3A4 AMEDEO MODIGLIANI

Portrait of a Woman, c. 1917–19

Oil on board, 21⅞ x 17¹¹/₁₆ in. (55.6 x 45 cm.)

Signed upper right: "modigliani"
Bequest of Joseph Winterbotham, 1954.316

3A5 CAPTAIN EDWARD MOLYNEUX, British, 1891–1974

A Rose, date uncertain

Oil on canvas board, 10^{11}/$_{16}$ x 8^{11}/$_{16}$ in. (27.2 x 22.1 cm.)
Signed lower right: "Molyneux"
Gift of Mrs. Laurance Armour, 1969.249

3A6 PIET MONDRIAN, Dutch, 1872–1944

Diagonal Composition, 1921

Oil on canvas, sight: 23^{5}/$_{8}$ x 23^{5}/$_{8}$ in. (60 x 60 cm.)
Signed and dated lower center: "P M / 21"
Gift of Edgar Kaufmann, Jr., 1957.307

3A7 PIET MONDRIAN

Composition Gray-Red, 1935

Oil on canvas, 22^{5}/$_{8}$ x 21^{7}/$_{8}$ in. (57.5 x 55.6 cm.)
Signed and dated lower right: "P M 35"
Gift of Mrs. Gilbert W. Chapman, 1949.518

3A8 CLAUDE MONET, French, 1840–1926

Pool of Water Lilies, 1900

Oil on canvas, 35^{3}/$_{8}$ x 39^{3}/$_{4}$ in. (89.9 x 101 cm.)
Signed and dated upper left: "Claude Monet / 1900"
Mr. and Mrs. Lewis Larned Coburn Memorial, 1933.441

3A9 CLAUDE MONET

Charing Cross Bridge, London, 1901

Oil on canvas, 25^{3}/$_{4}$ x 36^{3}/$_{8}$ in. (65.4 x 92.4 cm.)
Signed and dated lower right: "Claude Monet 1901"
Mr. and Mrs. Martin A. Ryerson Collection, 1933.1150

3A10 CLAUDE MONET

Vétheuil, 1901

Oil on canvas, sight: 34^{3}/$_{4}$ x 35^{5}/$_{8}$ in. (88.3 x 90.5 cm.)
Signed and dated lower left: "Claude Monet 1901"
Mr. and Mrs. Lewis Larned Coburn Memorial, 1933.447

3A11 CLAUDE MONET

Vétheuil at Sunset, 1901

Oil on canvas, 35¼ x 36½ in. (89.5 x 92.7 cm.)
Signed and dated lower left: "Claude Monet 1901"
Mr. and Mrs. Martin A. Ryerson Collection, 1933.1161

3A12 CLAUDE MONET

Houses of Parliament, Westminster, 1903

Oil on canvas, sight: 30⅞ x 35½ in. (78.4 x 90.2 cm.)
Signed lower right: "Claude Monet"
Mr. and Mrs. Martin A. Ryerson Collection, 1933.1164

3B1 CLAUDE MONET

Waterloo Bridge, 1903

Oil on canvas, 25⅞ x 39¾ in. (65.7 x 101 cm.)
Signed and dated lower right: "Claude Monet 1903"
Mr. and Mrs. Martin A. Ryerson Collection, 1933.1163

3B2 CLAUDE MONET

Water Lilies, c. 1905–10

Oil on canvas, 51⅜ x 60 in. (130.5 x 152.4 cm.)
Signed with estate stamp lower left: "Claude Monet";
signed with estate stamp on verso and stretcher
Gift of Mr. and Mrs. Edward Morris, 1964.201

3B3 CLAUDE MONET

Water Lilies, 1906

Oil on canvas, sight: 34½ x 36½ in. (87.6 x 92.7 cm.)
Signed and dated lower right: "Claude Monet 1906"
Mr. and Mrs. Martin A. Ryerson Collection, 1933.1157

3B4 CLAUDE MONET

Venice, Palazzo Dario, 1908

Oil on canvas, sight: 25½ x 31¾ in. (64.8 x 80.7 cm.)
Signed and dated lower left: "Claude Monet 1908"
Mr. and Mrs. Lewis Larned Coburn Memorial, 1933.446

3B5 CLAUDE MONET

Venice, San Giorgio Maggiore, 1908

Oil on canvas, sight: 25½ x 35⅝ in. (64.8 x 90.5 cm.)
Signed and dated lower left: "Claude Monet 1908"
Mr. and Mrs. Martin A. Ryerson Collection, 1933.1160

3B6 CLAUDE MONET

Iris by the Pond, c. 1919–25

Oil on canvas, 78¾ x 79⅛ in. (200 x 201 cm.)
Signed with estate stamp lower right: "Claude Monet"; stamped on verso
Art Institute Purchase Fund, 1956.1202

3B7 GABRIELE MÜNTER, German, 1877–1962

Still Life with Queen, 1912

Oil on canvas, 31⅜ x 24⅛ in. (79.7 x 61.3 cm.)
Signed and dated center left: "Münter / 1912"
Arthur Jerome Eddy Memorial Collection, 1931.521

3B8 BEN NICHOLSON, British, b. 1894

November 1956 (Pistoia), 1956

Oil on masonite, sight: 47¼ x 83½ in. (120 x 212.1 cm.)
Not signed on recto; signed, dated, and titled on verso
Joseph Winterbotham Collection, 1962.776

3B9 EMIL NOLDE (EMIL HANSEN), German, 1867–1956

Figure and Flowers, c. 1915

Oil on canvas, 23⅞ x 18⅞ in. (60.6 x 47.9 cm.)
Signed lower right: "Emil Nolde"; signed and titled on stretcher
Gift of Richard Feigen, 1967.729

3B10 SIR WILLIAM ORPEN, British, 1878–1931

The Old Cabman, 1907

Oil on canvas, 30¼ x 25¼ in. (76.8 x 64.1 cm.)
Signed lower left: "William ORPEN"
Charles H. and Mary F. S. Worcester Collection, 1929.918

3B11 SIR WILLIAM ORPEN

Woman in Gray, 1908

Oil on canvas, 74¼ x 49¼ in. (188.6 x 125.1 cm.)
Signed lower left: "ORPEN"
Samuel P. Avery Fund, 1912.1627

3B12 AMÉDÉE OZENFANT, French, 1886–1966

Landscape, 1918

Oil on canvas, sight: 21 x 16⅝ in. (53.3 x 42.2 cm.)

Signed and dated lower left: "a. Ozenfant 1918"
Bequest of Kate L. Brewster, 1950.126

3C1 JULES PASCIN, Bulgarian/American, 1885–1930

Hermine David, 1907

Oil on canvas, 26 x 21¾ in. (66 x 55.3 cm.)
Signed and dated lower left: "pascin / 1907"; signed
and inscribed on stretcher
Gift of Mr. and Mrs. Carter H. Harrison, 1936.12

3C2 JULES PASCIN

Hermine David with Violin, 1907

Oil on pulpboard, mounted on masonite, 25⁹/₁₆ x 21
in. (65 x 53.3 cm.)
Not signed
Gift of Mr. and Mrs. Carter H. Harrison, 1937.386

3C3 JULES PASCIN

Claudine Resting, 1923

Oil on canvas, 31⅞ x 23⅝ in. (81 x 60 cm.)
Signed lower right: "pascin"
Gift of Mr. and Mrs. Carter H. Harrison, 1936.11

3C4 JULES PASCIN

Little Girl, 1927

Oil on canvas, 36¼ x 28¾ in. (92.1 x 73 cm.)
Signed lower left: "pascin"
Gift of Mr. and Mrs. Carter H. Harrison, 1935.307

3C5 VICTOR PASMORE, British, b. 1908

Linear Development No. 1, 1965

Oil and gravure on wood, 60 x 60 in. (152.4 x 152.4
cm.)
Not signed on recto; signed and dated on verso
Gift of Mr. and Mrs. Solomon B. Smith, 1965.689

3C6 FRANCIS PICABIA, French, 1879–1953

Edtaonisl, 1913

Oil on canvas, 118¼ x 118⅜ in. (300.4 x 300.7 cm.)
Signed and dated lower right: "Picabia 1913"; titled
upper right of center: "EDTAONISL"
Gift of Mr. and Mrs. Armand Phillip Bartos, 1953.622

3C7 FRANCIS PICABIA

Têtes-Paysage, 1928

Oil on canvas, 23¾ x 32 in. (60.3 x 81.3 cm.)
Signed lower left: "Francis Picabia"
Gift of Mr. and Mrs. Leigh B. Block, 1966.476

3C8 PABLO PICASSO, Spanish, 1881–1973

On the Upper Deck (The Omnibus), 1901

Oil on cardboard, mounted on panel, 19⅛ x 25⅜ in.
(48.6 x 64.5 cm.)
Signed lower right: "Picasso"
Mr. and Mrs. Lewis Larned Coburn Memorial, 1933.448

3C9 PABLO PICASSO

Woman with Cats, 1901

Oil on cardboard, mounted on panel, sight: 17⅛ x
15½ in. (43.5 x 39.4 cm.)
Signed lower right: "Picasso"
Amy McCormick Memorial Collection, 1942.464

3C10 PABLO PICASSO

The Old Guitarist, 1903

Oil on panel, 48⅜ x 32½ in. (122.9 x 82.6 cm.)
Signed lower right: "Picasso"
Helen Birch Bartlett Memorial Collection, 1926.253

3C11 PABLO PICASSO

Head of the Acrobat's Wife, 1904

Gouache on illustration board, sight: 16⅜ x 11¾ in.
(41.6 x 29.9 cm.)
Signed and dated upper left: "Picasso / 1904"
Bequest of Kate L. Brewster, 1950.128

3C12 PABLO PICASSO

Bust of a Woman, 1906

Oil on canvas, mounted on panel, 32³/₁₆ x 26 in.
(81.8 x 66 cm.)
Signed upper right: "Picasso"
Gift of Florene May Schoenborn and Samuel A. Marx,
1959.619

3D1 PABLO PICASSO

Head of a Woman, 1909

 Oil on canvas, 23⅞ x 20³/₁₆ in. (60.6 x 51.3 cm.)
 Not signed
Joseph Winterbotham Collection, 1940.5

3D2 PABLO PICASSO

Daniel-Henry Kahnweiler, 1910

 Oil on canvas, 39¹³/₁₆ x 28⅞ in. (101.1 x 73.3 cm.)
 Not signed
Gift of Mrs. Gilbert W. Chapman in memory of Charles
B. Goodspeed, 1948.561

3D3 PABLO PICASSO

Man with a Pipe, 1915

 Oil on canvas, 51¼ x 35¼ in. (130.2 x 89.5 cm.)
 Signed and dated lower right: "Picasso / 15"
Gift of Mrs. Leigh B. Block in memory of Albert D.
Lasker, 1952.1116

3D4 PABLO PICASSO

Mother and Child, 1921

 Oil on canvas, 56¼ x 68 in. (142.9 x 172.7 cm.)
 Signed and dated lower right: "Picasso / 21"
Gift of Mary and Leigh Block Charitable Fund, Mr. and
Mrs. Edwin E. Hokin, Maymar Corporation, Mr. and
Mrs. Chauncey McCormick, Mrs. Maurice L. Rothschild,
and Ada Turnbull Hertle Fund, 1954.270

3D5 PABLO PICASSO

Fragment of Mother and Child, 1921

 Oil on canvas, 56⁷/₁₆ x 17⁷/₁₆ in. (143.4 x 44.3 cm.)
 Not signed
Gift of Pablo Picasso, 1968.100

3D6 PABLO PICASSO

Still Life, 1922

 Oil on canvas, 32⅛ x 39⅝ in. (81.6 x 100.7 cm.)
 Dated upper left: "4–2–22–"
Ada Turnbull Hertle Fund, 1953.28

3D7 PABLO PICASSO

Head, 1927

Oil and plaster on canvas, 39⅜ x 31⅞ in. (100 x 81 cm.)

Not signed

Gift of Florene May Schoenborn and Samuel A. Marx, 1951.185

3D8 PABLO PICASSO

Abstraction (Background with Blue Cloudy Sky), 1930

Oil on panel, 26 x 19⅜ in. (66 x 49.2 cm.)

Signed and dated lower right: "Picasso / 4–I–xxx"

Gift of Florene May Schoenborn and Samuel A. Marx and the Wilson L. Mead Fund, 1955.748

3D9 PABLO PICASSO

The Red Armchair, 1931

Oil and enamel on panel, 51⅝ x 38⅞ in. (131.1 x 98.7 cm.)

Signed upper right: "Picasso"

Gift of Mr. and Mrs. Daniel Saidenberg, 1957.72

3D10 PABLO PICASSO

Still Life in Front of the Window, 1934

Oil on canvas, 32 x 38⁷⁄₁₆ in (81.3 x 97.6 cm.)

Signed, dated, and inscribed lower left: "Picasso / Boisgeloup / 5 avril xxxiv"

Anonymous gift, 1968.308

3D11 PABLO PICASSO

Seated Woman (Femme assise), 1949

Oil on canvas, 45½ x 35 in. (115.6 x 88.9 cm.)

Signed and dated upper left: "20.2.49. / Picasso"; dated on verso

Gift of Muriel Kallis Newman, 1975.640

3D12 PABLO PICASSO

The Reader (La Lecture), 1953

Oil on canvas on plywood, 36³⁄₁₆ x 28⅝ in. (92 x 72.7 cm.)

Signed upper right: "Picasso"; dated and inscribed on verso
Gift of Mr. and Mrs. Arnold H. Maremont through the Kate Maremont Foundation, 1956.336

3E1 PABLO PICASSO

Sylvette (Portrait of Mlle D.), 1954
> Oil on canvas, 51^7/$_{16}$ x 38^1/$_{16}$ in. (130.7 x 96.7 cm.)
> Signed upper left: "Picasso"; dated on verso
Gift of Mr. and Mrs. Leigh B. Block, 1955.821

3E2 PABLO PICASSO

Nude under a Pine Tree, 1959
> Oil on canvas, sight: 76 x 109 in. (193 x 276.9 cm.)
> Signed lower right: "Picasso"; dated on verso
Bequest of Grant J. Pick, 1965.687

3E3 SERGE POLIAKOFF, Russian/French, 1906–69

Untitled, 1954
> Oil on canvas, 38^1/$_8$ x 51 in. (96.8 x 129.5 cm.)
> Signed lower right: "SErgE POLiAKOFF"
Gift of Mrs. Edwin E. Hokin, 1965.365

3E4 SERGE POLIAKOFF

Composition, 1960
> Oil on canvas, 38^5/$_8$ x 51^1/$_4$ in. (98.1 x 130.2 cm.)
> Signed lower right: "SErgE POLiAKOFF"
Gift of Mr. and Mrs. Leigh B. Block, 1967.691

3E5 PEDRO PRUNA, Spanish, 1904–77

Portrait of Woman in White, 1934
> Oil on canvas, 63^5/$_8$ x 32^5/$_8$ in. (161.6 x 82.9 cm.)
> Signed and dated lower right: "Pruna / 34"
Gift of Mrs. Gilbert W. Chapman, 1956.340

3E6 JAMES PRYDE, British, 1866–1941

A Small Tower (Moonlight), c. 1910–12
> Oil on canvas, 16^3/$_{16}$ x 12 in. (41.1 x 30.5 cm.)
> Not signed
Gift of George F. Porter, 1927.532

3E7 ODILON REDON, French, 1840–1916

Andromeda, c. 1905–8

Oil on paper, mounted on cardboard, 22$^{1}/_{16}$ x 21$^{5}/_{16}$ in. (56 x 54.1 cm.)
Signed lower left: "ODILON REDON"
Mr. and Mrs. Martin A. Ryerson Collection, 1933.1167

3E8 ODILON REDON

Still Life: Vase with Flowers, c. 1910

Oil on cardboard, mounted on panel, 27 x 21 in. (68.6 x 53.3 cm.)
Signed lower right: "ODILON REDON"
Mr. and Mrs. Lewis Larned Coburn Memorial, 1933.450

3E9 PIERRE AUGUSTE RENOIR, French, 1841–1919

The Artist's Son Jean, 1900

Oil on canvas, 22 x 18$^{1}/_{4}$ in. (55.9 x 46.4 cm.)
Signed lower left: "Renoir"
Mr. and Mrs. Martin A. Ryerson Collection, 1937.1027

3E10 PIERRE AUGUSTE RENOIR

Woman Sewing in a Garden, after 1900

Oil on canvas, 11$^{15}/_{16}$ x 10$^{3}/_{8}$ in. (30.3 x 26.4 cm.)
Signed lower left: "Renoir"
Charles H. and Mary F. S. Worcester Collection, 1947.103

3E11 PIERRE AUGUSTE RENOIR

Seated Nude, 1916

Oil on canvas, 32$^{1}/_{16}$ x 26$^{9}/_{16}$ in. (81.4 x 67.5 cm.)
Signed and dated lower left: "Renoir.1916"
Gift of Annie Swan Coburn to the Mr. and Mrs. Lewis Larned Coburn Memorial, 1945.27

3E12 PIERRE AUGUSTE RENOIR

Andrée in a Grecian Gown, 1917

Oil on canvas, 17 x 15$^{3}/_{8}$ in. (43.2 x 39.1 cm.)
Signed with estate stamp lower left: "Renoir"
Bequest of John J. Ireland, 1968.95

3F1 PIERRE AUGUSTE RENOIR

Flowers (Bouquet de fleurs), c. 1917–18

Oil on canvas, 17¹¹/₁₆ x 15¹¹/₁₆ in. (45 x 39.9 cm.)
Signed with estate stamp lower left: "Renoir"
Gift of Joseph Winterbotham, 1954.321

3F2 BRIDGET RILEY, British, b. 1931

Ascending and Descending Hero, 1965

Emulsion on canvas, 72¹/₁₆ x 108⁵/₁₆ in. (183 x 275.1 cm.)
Not signed on recto; signed, dated, titled, and in-scribed on verso
Gift of the Society for Contemporary Art, 1968.102

3F3 JEAN-PAUL RIOPELLE, Canadian, b. 1923

Abstraction: La Proue, 1957

Oil on canvas, 28³/₄ x 36¹/₁₆ in. (73 x 91.6 cm.)
Signed lower right: "riopelle"; signed on stretcher
Gift of Mrs. Gilbert W. Chapman, 1962.907

3F4 JEAN-PAUL RIOPELLE

Painting 1957, 1957

Oil on canvas, 31⅞ x 39⁷/₁₆ in. (81 x 100.2 cm.)
Signed lower right: "riopelle"; signed on stretcher
Gift of Mr. and Mrs. Roy J. Friedman, 1970.93

3F5 JEAN-PAUL RIOPELLE

Vespéral, 1957

Oil on canvas, 44⅞ x 63³/₄ in. (114 x 162 cm.)
Signed lower right: "riopelle"; signed on stretcher
Mary and Leigh Block Fund for Acquisitions, 1963.263

3F6 GIOVANNI ROMAGNOLI, Italian, 1893–1976

Girl Eating Fruit, 1924

Oil on canvas, 31⅛ x 26⁵/₁₆ in. (79.1 x 66.8 cm.)
Signed upper left: "Giov Romagnoli"; signed on stretcher
Charles H. and Mary F. S. Worcester Collection, 1947.106

3F7 GIOVANNI ROMAGNOLI

Summer (Nude), c. 1925

Oil on panel, 5³/₈ x 12 in. (13.7 x 30.5 cm.)
Not signed on recto; signed on verso
Charles H. and Mary F. S. Worcester Collection, 1947.105

3F8 GEORGES ROUAULT, French, 1871–1958

The Academician, c. 1913–15

Oil on canvas, 41⅞ x 29⅞ in. (106.4 x 75.9 cm.)
Signed lower right: "G. Rouault"; titled on stretcher
Gift of Mrs. Leigh B. Block in memory of Albert D. Lasker, 1958.192

3F9 GEORGES ROUAULT

The Three Judges, 1928

Oil and gouache on paper, mounted on cardboard and backed with canvas, 29⁹/₁₆ x 21⅝ in. (75.1 x 55 cm.)
Signed and dated lower right: "G. Rouault / 1928"
Gift of Florene May Schoenborn and Samuel A. Marx, 1954.1309

3F10 GEORGES ROUAULT

The Dwarf, c. 1936

Oil on canvas, 27¼ x 19¹¹/₁₆ in. (69.2 x 50 cm.)
Signed lower right: "G Rouault"; signed, titled, and inscribed on verso; inscribed on stretcher
Gift of Mr. and Mrs. Max Epstein, 1946.96

3F11 GEORGES ROUAULT

L'Italienne, 1937

Oil on canvas, 15⅞ x 11⅝ in. (40.3 x 29.5 cm.)
Signed lower right: 'G Rouault"; signed, titled, and inscribed on verso
Gift of Mrs. Gilbert W. Chapman, 1951.245

3F12 HENRI ROUSSEAU (LE DOUANIER), French, 1844–1910

Flowers, c. 1905

Oil on canvas, 13 x 9½ in. (33 x 24.1 cm.)
Signed lower right: "Henri Rousseau"
Gift of Emily Crane Chadbourne, 1953.6

3G1 HENRI ROUSSEAU (LE DOUANIER)

The Waterfall, 1910

Oil on canvas, 45¾ x 59⅛ in. (116.2 x 150.2 cm.)
Signed and dated lower right: "Henri Rousseau / 1910"
Helen Birch Bartlett Memorial Collection, 1926.262

3G2 KER-XAVIER ROUSSEL, French, 1867–1944

Flowers, 1904
>Oil on panel, sight: 29⅝ x 41¾ in. (75.3 x 106.1 cm.)
>Signed lower right: "k. x. roussel"

Gift of Sam Salz, 1962.484

3G3 Russian, Twentieth Century

Portrait of Gontcharova and Larionov, c. 1910
>Oil on canvas, sight: 41 x 54 in. (104.1 x 137.2 cm.)
>Not signed on recto; oil and charcoal sketch on verso

Mary and Leigh Block Fund for Acquisitions, 1975.666

3G4 KARL SCHMIDT-ROTTLUFF, German, 1884–1976

Girls in a Garden, 1914
>Oil on canvas, sight: 38½ x 33½ in. (97.8 x 85.1 cm.)
>Signed and dated left of center: "S. Rottluff 1914"

Gift of Mr. and Mrs. Stanley Freehling in memory of Juliet S. Freehling, 1959.212

3G5 KURT SCHWITTERS, German, 1887–1948

Aerated VIII, 1942
>Oil and collage on canvas, sight: 19½ x 15½ in. (49.5 x 39.4 cm.)
>Signed, dated, and titled lower center: "Kurt Schwitters 1942 / Aerated VIII"

Robert A. Waller Fund, 1959.19

3G6 GINO SEVERINI, Italian, 1883–1966

Still life with Picture, 1916
>Oil on canvas, sight: 25½ x 23⅜ in. (64.8 x 59.4 cm.)
>Signed lower right: "Severini"; signed, titled, and inscribed on verso

Alfred Stieglitz Collection, 1949.581

3G7 GINO SEVERINI

Still Life: Barbera, 1918
>Oil on panel, 18⅛ x 10⅞ in. (46 x 27.6 cm.)
>Signed lower right: "G. Severini"; signed and dated on verso

Gift of Mr. and Mrs. Daniel Saidenberg, 1955.819

3G8 LUCIEN SIMON, French, 1861–1945

Self-Portrait, c. 1900

Oil on canvas, 38⅜ x 27¾ in. (97.5 x 70.5 cm.)
Signed upper left: "LSimon"
Stickney Fund, 1921.86

3G9 MARIO SIRONI, Italian, 1885–1961

Composition, 1949

Oil on pulpboard, 31⅜ x 23½ in. (79.7 x 59.7 cm.)
Signed lower left: "SIRONI"
Bequest of Maxine Kunstadter, 1978.403

3G10 JOAQUIN SOROLLA Y BASTIDA, Spanish, 1863–1923

Two Sisters, Valencia, 1909

Oil on canvas, 69⅜ x 44⅛ in. (176.2 x 112.1 cm.)
Signed and dated lower right: "J Sorolla / 1909"
Gift of Mrs. William Stanley North in memory of William
Stanley North, 1911.28

3G11 PIERRE SOULAGES, French, b. 1919

17 March 1960, 1960

Oil on canvas, sight: $50^{5}/_{16}$ x 63⅛ in. (127.8 x 160.3
cm.)
Signed lower right: "soulages"; signed and dated on
verso
Gift of Mr. and Mrs. Leigh B. Block, 1965.1171

3G12 CHAIM SOUTINE, Lithuanian, 1893–1943

Landscape at Cagnes, c. 1923

Oil on canvas, $23^{13}/_{16}$ x 28¾ in. (60.5 x 73 cm.)
Signed lower left: "Soutine"
Charles H. and Mary F. S. Worcester Collection, 1947.114

4A1 CHAIM SOUTINE

Dead Fowl, c. 1926

Oil on canvas, sight: 37¾ x 24¼ in. (95.9 x 61.6 cm.)
Signed lower left: "Soutine"
Joseph Winterbotham Collection, 1937.167

4A2 CHAIM SOUTINE

Small Town Square, Vence, 1929

Oil on canvas, 28⅛ x 18 in. (71.4 x 45.7 cm.)
Signed lower right: "Soutine"
Joseph Winterbotham Collection, 1931.709

4A3　AMADEO DE SOUZA-CARDOSO, Portuguese, 1887–1918

Marine: Pont L'Abbé, 1909

Oil on canvas, 19⅞ x 24⅛ in. (50.5 x 61.3 cm.)
Signed and dated lower right: "A. de S.CARDOZO [sic] / 1909"
Arthur Jerome Eddy Memorial Collection, 1931.513

4A4　AMADEO DE SOUZA-CARDOSO

The Leap of the Rabbit, 1911

Oil on canvas, 19¾ x 24¼ in. (50.2 x 61.6 cm.)
Signed and dated lower left: "A. DE SOUSA CARDOZO [sic] / 1911"
Arthur Jerome Eddy Memorial Collection, 1931.514

4A5　AMADEO DE SOUZA-CARDOSO

The Stronghold, c. 1911

Oil on canvas, 36⅜ x 24 in. (92.4 x 61 cm.)
Not signed
Arthur Jerome Eddy Memorial Collection, 1931.512

4A6　NICOLAS DE STAËL, Russian/French, 1914–55

Composition, 1946

Oil on canvas, 39⁵/₁₆ x 25⁹/₁₆ in. (99.9 x 64.9 cm.)
Signed lower left: "Staël"; signed and dated on verso
Gift of Mr. and Mrs. William Wood-Prince, 1963.210

4A7　KUMI SUGAÏ, Japanese, b. 1919

Akatsuki, 1960

Oil on canvas, 76¾ x 51¼ in. (195 x 130.2 cm.)
Signed and dated lower right: "SUGAÏ / 60"; signed, dated and titled on verso
Gift of Keith Wellin, 1971.784

4A8　YVES TANGUY, French/American, 1900–1955

The Rapidity of Sleep, 1945

Oil on canvas, 50 x 40 in. (127 x 101.6 cm.)
Signed and dated lower right: "YVES TANGUY 45"
Joseph Winterbotham Collection, 1946.46

4A9 YVES TANGUY

Ajourer les étoiles, 1951

Oil on canvas, $29^{15}/_{16}$ x $25^{1}/_{16}$ in. (76 x 63.7 cm.)
Signed and dated lower right: "YVES TANGUY 51"
Bequest from the Estate of Kay Sage Tanguy, 1964.1140

4A10 MAURICE UTRILLO, French, 1883–1955

Rue St Vincent, Paris, 1913

Oil on canvas, $25^{3}/_{16}$ x $39^{7}/_{8}$ in. (64 x 101.3 cm.)
Signed and dated lower right: "Maurice.Utrillo.V. / 20
Juin 1913"; signed on stretcher
Mr. and Mrs. Martin A. Ryerson Collection, 1933.1179

4A11 MAURICE UTRILLO

Street in Paris, 1914

Oil on canvas, $25^{3}/_{4}$ x $31^{13}/_{16}$ in. (65.4 x 80.8 cm.)
Signed and dated lower right: "Maurice.Utrillo.V.
1914"
Helen Birch Bartlett Memorial Collection, 1926.226

4A12 MAURICE UTRILLO

The Tavern "La Belle Gabrielle," 1916

Oil on cardboard, $18^{1}/_{16}$ x $21^{5}/_{8}$ in. (45.9 x 55 cm.)
Signed lower right: "Maurice.Utrillo.V."; dated and
inscribed on verso
Gift of Mr. and Mrs. Carter H. Harrison, 1935.310

4B1 MAURICE UTRILLO

Street Corner, Montmartre, c. 1920

Oil on cardboard, $19^{13}/_{16}$ x $29^{11}/_{16}$ in. (50.3 x 75.4 cm.)
Signed lower right: "Maurice.Utrillo.V."; signed and
inscribed on verso
Gift of Mr. and Mrs. Carter H. Harrison, 1937.387

4B2 MAURICE UTRILLO

Argentan, Orne, 1922

Oil on canvas, $19^{11}/_{16}$ x $25^{1}/_{2}$ in. (50 x 64.8 cm.)
Signed and dated lower left: "Maurice.Utrillo.V. /
1922"; signed, dated, and titled on verso
Gift of Joseph Winterbotham, 1954.323

4B3　Félix Vallotton, Swiss/French, 1865–1925

Nude, 1911

Oil on canvas, 35¼ x 45¾ in. (89.5 x 116.2 cm.)
Signed and dated upper right: "F. VALLOTTON. 11"
Gift of Mr. and Mrs. Chester Dale, 1945.18

4B4　Kees van Dongen (Cornelis T. M. van Dongen), Dutch/
French, 1877–1968

Woman against White Background, c. 1914

Oil on canvas, 51⅜ x 32 in. (130.5 x 81.3 cm.)
Signed lower center: "van Dongen"
Gift of Mr. and Mrs. Carter H. Harrison, 1946.48

4B5　Kees van Dongen

Rue de la Paix, Paris, c. 1922–23

Oil on canvas, 39⁷/₁₆ x 31¹⁵/₁₆ in. (100.2 x 81.1 cm.)
Signed lower right: "van Dongen"; signed and in-
scribed on verso
Gift of Mr. and Mrs. Carter H. Harrison, 1935.303

4B6　Kees van Dongen

Tea in My Studio, c. 1922–23

Oil on canvas, 36³/₁₆ x 29¾ in. (91.9 x 75.6 cm.)
Signed lower right: "van Dongen"; signed and in-
scribed on verso
Gift of Mr. and Mrs. Carter H. Harrison, 1936.7

4B7　Victor Vasarely, Hungarian/French, b. 1908

Capella, 1964

Oil on canvas, 78¾ x 39¼ in. (200 x 99.7 cm.)
Signed lower center: "Vasarely"; signed, dated, titled,
and inscribed on verso
Gift of Mr. and Mrs. Solomon B. Smith, 1965.690

4B8　Victor Vasarely

Harmas, 1964

Oil and acrylic on canvas, 74¼ x 70⅞ in. (188.6 x 180
cm.)
Signed lower right: "vasarely"; signed, dated, titled,
and inscribed on verso
Mary and Leigh Block Fund for Acquisitions, 1966.2

4B9 HENRI VERGÉ-SARRAT, Belgian, 1880–1966

Quay at Calvi, Corsica, 1936

Oil on canvas, 23¹¹/₁₆ x 28¾ in. (60.2 x 73 cm.)
Signed and dated lower right: "Vergé-Sarrat. 1936";
titled and inscribed on verso
Gift of Mr. and Mrs. Carter H. Harrison, 1936.13

4B10 HENRI VERGÉ-SARRAT

Terrace at Calenzana, Corsica, 1936

Oil on canvas, 28⅞ x 36⅛ in. (73.3 x 91.8 cm.)
Signed lower right: "Vergé-Sarrat"; titled and in-
scribed on verso
Gift of Mr. and Mrs. Carter H. Harrison, 1937.388

4B11 MARIA ELENA VIEIRA DA SILVA, Portuguese/French, b.
1908

Composition, c. 1938–39

Oil on canvas, 32⅛ x 39⅝ in. (81.6 x 100.7 cm.)
Not signed
Bequest of Maxine Kunstadter, 1978.404

4B12 MARIA ELENA VIEIRA DA SILVA

Rotterdam, 1956

Oil on canvas, 25½ x 18 in. (64.8 x 45.7 cm.)
Signed and dated lower right: "Vieira da Silva / 56"
Bequest of Maxine Kunstadter, 1978.405

4C1 JACQUES VILLON, French, 1875–1963

Musical Instruments, 1912

Oil on panel, 43½ x 32¾ in. (110.5 x 83.2 cm.)
Signed and dated lower left: "Jacques Villon 12"
Gift of Mr. and Mrs. Francis Steegmuller, 1942.305

4C2 JACQUES VILLON

Portrait of Marcel Duchamp, 1950

Oil on canvas, 13⅛ x 9⁹/₁₆ in. (33.3 x 24.3 cm.)
Signed and dated lower left: "JACQUES VILLON / 50";
signed, dated, and titled on verso
Bequest of Maxine Kunstadter, 1978.406

4C3 MAURICE DE VLAMINCK, French, 1876–1958

Houses at Chatou, c. 1905–6

Oil on canvas, 32 x 40 in. (81.3 x 101.6 cm.)
Signed lower left: "Vlaminck"
Gift of Mr. and Mrs. Maurice E. Culberg, 1951.19

4C4 MAURICE DE VLAMINCK

Village (Rueil), c. 1912

Oil on canvas, 28¹/₁₆ x 36⅛ in. (71.3 x 91.8 cm.)
Signed lower right: "Vlaminck"
Arthur Jerome Eddy Memorial Collection, 1931.517

4C5 MAURICE DE VLAMINCK

Near Pontoise, c. 1918–20

Oil on canvas, 31⅞ x 39¼ in. (81 x 99.7 cm.)
Signed lower left: "Vlaminck"
Gift of Mr. and Mrs. Carter H. Harrison, 1935.311

4C6 MAURICE DE VLAMINCK

Bouquet in a Gray Vase, c. 1930

Oil on canvas, 12½ x 9¼ in. (31.8 x 23.5 cm.)
Signed lower right: "Vlaminck"
Bequest of Kate L. Brewster, 1950.135

4C7 MAURICE DE VLAMINCK

Landscape (The Red Barn), 1940s

Oil on canvas, 23¾ x 28¾ in. (60.3 x 73 cm.)
Signed lower left: "Vlaminck"
Gift of Mr. and Mrs. Seymour Oppenheimer, 1961.1110

4C8 ÉDOUARD VUILLARD, French, 1868–1940

Child in a Room, c. 1900

Oil on cardboard, 17¼ x 22¾ in. (43.8 x 57.8 cm.)
Signed upper right: "E Vuillard"
Mr. and Mrs. Martin A. Ryerson Collection, 1933.1180

4C9 ÉDOUARD VUILLARD

Interior, 1903

Oil on cardboard, mounted on panel, 17⅞ x 24⅜ in.
(45.4 x 62 cm.)

Signed and dated lower right: "E Vuillard 03"
Gift of the Estate of Dorothy C. Morris, 1975.130

4C10 ÉDOUARD VUILLARD

Interior with Seated Woman, c. 1904–5

Tempera and oil on cardboard, mounted on cardboard,
17⁷/16 x 14¹⁵/16 in. (44.3 x 38 cm.)
Signed lower right: "E Vuillard"
Charles H. and Mary F. S. Worcester Collection, 1947.118

4C11 ÉDOUARD VUILLARD

Still Life (Les Boules de neige), 1905

Oil on cardboard, 29 x 25³/8 in. (73.7 x 64.5 cm.)
Signed and dated lower left: "E Vuillard 1905"
Gift of Mr. and Mrs. Sterling Morton, 1959.4

4C12 ÉDOUARD VUILLARD

Woman Seated on a Sofa, c. 1906

Oil and tempera on cardboard, 19½ x 24⅞ in. (49.5 x
63.2 cm.)
Signed lower right: "E Vuillard"
Charles H. and Mary F. S. Worcester Collection, 1947.119

4D1 ÉDOUARD VUILLARD

Woman in Interior, 1932

Tempera and pastel on paper, mounted on canvas,
28¾ x 36¼ in. (73 x 92 cm.)
Signed with estate stamp lower right: "E Vuillard"
Gift of Mrs. George L. Simmonds, 1959.508

4D2 ÉDOUARD VUILLARD

Interior, 1935

Tempera on paper, mounted on canvas, 30⅝ x 39⁷/16
in. (77.8 x 100.2 cm.)
Signed lower right: "E. Vuillard"
Gift of Mr. and Mrs. Leigh B. Block, 1973.337

4D3 JACK B. YEATS, British, 1871–1957

Roadsters Old and Young, 1956

Oil on canvas, 18 x 24 in. (45.7 x 61 cm.)
Signed lower left: "JACK B YEATS"; titled on stretcher
Bequest of Maxine Kunstadter, 1978.407

4D4 EUGÈNE ZAK, Polish, 1884–1926

The Shepherd, c. 1910
 Oil on canvas, 46 x 31⅞ in. (116.8 x 81 cm.)
 Signed lower right: "Eug. Zak"
Arthur Jerome Eddy Memorial Collection, 1931.519

4D5 ZAO WOU-KI, Chinese/French, b. 1921

The Wolf and the Deer, c. 1951–52
 Oil on canvas, 34¼ x 45 in. (87 x 114.3 cm.)
 Signed lower right: "[Chinese characters] ZAO"
Gift of James W. Alsdorf, 1954.1203

4D6 ZAO WOU-KI

La Nuit remue, 1956
 Oil on canvas, 76⅝ x 51³/₁₆ in. (194.6 x 130 cm.)
 Signed and dated lower right: "[Chinese characters]
ZAO 56"; signed, dated, titled, and inscribed on verso
Gift of Mr. and Mrs. Samuel M. Kootz, 1962.904

4D7 ZAO WOU-KI

Abstraction, 1958
 Oil on canvas, 51½ x 63⅞ in. (130.8 x 162.2 cm.)
 Signed and dated lower right: "[Chinese characters]
ZAO 58"; signed, dated, and inscribed on verso
Mary and Leigh Block Fund for Acquisitions, 1961.789

4D8 ANDERS ZORN, Swedish, 1860–1920

Nude Girl in Doorway, c. 1900
 Oil on canvas, 20⅛ x 13½ in. (51.1 x 34.3 cm.)
 Signed lower right: "Zorn"
Gift of Mrs. Chauncey McCormick and Mrs. Richard E.
Danielson, 1945.176

4D9 ANDERS ZORN

Portrait Study of a Man, 1901
 Oil on canvas, 30 x 25 in. (76.2 x 63.5 cm.)
 Signed and dated upper left: "Zorn 1901"
Anonymous gift, 1951.316

4D10 ANDERS ZORN

Interior with Nudes, 1905

Oil on canvas, 42³/₁₆ x 32½ in. (107.2 x 82.6 cm.)
Signed and dated lower left: "Zorn / 1905"
Gift of Woodruff J. Parker, 1926.429

4D11 IGNACIO ZULOAGA, Spanish, 1870–1945

The Actress Consuelo, early 1920s

Oil on canvas, 83¹¹/₁₆ x 59⅞ in. (212.6 x 152.1 cm.)
Signed lower right: "I.Zuloaga"
Wirt D. Walker Fund, 1925.918

Selected Bibliography

Antiquarian Society, Art Institute of Chicago. *The Mrs. L. L. Coburn Collection: Modern Paintings and Water Colors.* Chicago: Art Institute of Chicago, 1932. (Exhibition April 6–October 9, 1932.)

Arnason, H. H. *History of Modern Art.* Rev. ed. New York: Harry N. Abrams, 1977.

The Arthur Jerome Eddy Collection of Modern Paintings and Sculpture. Chicago: Art Institute of Chicago, 1931. (Exhibition December 22, 1931–January 17, 1932.)

Art since Mid-Century: The New Internalism. Vols. 1 and 2. Greenwich: New York Graphic Society, 1971.

Bulliet, C. J. "How Modern Art Came to Town." *Chicagoan,* August, 1931, pp. 33–36, 64.

———. "The Eddy Gift to Chicago." *Creative Art,* 10 (March, 1932): 213–18.

———. *The Significant Moderns and Their Pictures.* New York: Covici, Friede, 1936.

———. "Winterbotham Collection United in Chicago." *Art Digest,* 21 (July 1, 1947): 9, 29.

Catalogue of the Charles H. and Mary F. S. Worcester Collection of Paintings, Sculpture and Drawings. Chicago: [Lakeside Press], 1938.

Cheney, Sheldon. *The Story of Modern Art.* New York: Viking Press, 1941.

"Chicago's Fabulous Collectors." *Life,* October 27, 1952, pp. 90–100.

"Chicago's Winterbotham Collection." *Art News,* 46 (September, 1947): 34–35, 43.

"Chicago's Worcester Collection." *Art News,* 46 (September, 1947): 36–37.

Contemporary Artists. Ed. Colin Naylor and Genesis P-Orridge. London: St. James Press; New York: St. Martin's Press, 1977.

Eddy, Arthur Jerome. *Cubists and Post-Impressionism*. Rev. ed. Chicago: A. C. McClurg, 1919.

Golding, John. *Cubism: A History and an Analysis, 1907–1914*. New York: George Wittenborn, 1959.

The Grant J. Pick Collection. Chicago: Art Institute of Chicago, 1970. (Exhibition, June 20–August 16, 1970).

Haftmann, Werner. *Painting in the Twentieth Century*. New York: Frederick A. Praeger, 1960.

Hamilton, George Heard. *Painting and Sculpture in Europe, 1880 to 1940*. Pelican History of Art. Harmondsworth: Penguin Books, 1967.

Hunter, Sam, and Jacobus, John. *Modern Art from Post-Impressionism to the Present*. New York: Harry N. Abrams in association with Alexis Gregory, 1976.

Kelley, Charles Fabens. "Chicago: Record Years." *Art News*, 51 (June–August, 1952): 52–65, 106–11.

Lippard, Lucy. *Six Years: The Dematerialization of the Art Object*. New York: Praeger; London: Studio Vista, 1973.

Maxon, John. *The Art Institute of Chicago*. New York: Harry N. Abrams, 1970; rev. ed., London: Thames & Hudson, 1977.

Meyer, Ursula. *Conceptual Art*. New York: E. P. Dutton, 1972.

Modern Paintings in the Helen Birch Bartlett Memorial from the Birch-Bartlett Collection. Chicago: Art Institute of Chicago, 1926; 1929; 1946.

Myers, Bernard Samuel. *The German Expressionists*. New York: Frederick A. Praeger, [1957].

Paintings in the Art Institute of Chicago. Chicago: Art Institute of Chicago, 1961.

Read, Herbert. *A Concise History of Modern Painting*. London: Thames & Hudson, 1974.

Rich, Daniel Catton. "The Art Institute of Chicago—and Chicago." *Art in America*, 32 (October, 1944): 247–53.

———. "The Bequest of Mrs. L. L. Coburn." *Bulletin of the Art Institute of Chicago*, 26 (November, 1932): 66–71.

———. "The Kate L. Brewster Bequest." *Bulletin of the Art Institute of Chicago*, 44 (September 15, 1950): 51–55.

———. "The Windy City, Storm Center of Many Contemporary Art Movements." *Art Digest*, 26 (November 1, 1951): 28–29, 82.

Richter, Hans. *Dada: Art and Anti-Art*. New York: Harry N. Abrams, 1964.

Rosenblum, Robert. *Cubism and Twentieth-Century Art*. Rev. ed. New York: Harry N. Abrams, 1976.

Rubin, William Stanley. *Dada and Surrealist Art*. New York: Harry N. Abrams, [1968].

"Ryerson Makes Princely Bequest to the Art Institute of Chicago." *Art Digest*, 6 (September 1, 1932): 3–4.

Schapiro, Meyer. *Modern Art: Nineteenth and Twentieth Centuries.* New York: George Braziller, 1978.

Selz, Peter. *German Expressionist Painting.* Berkeley: University of California Press, 1957.

Sherwood, Walter J. "The Famous Birch Bartlett Collection." *Chicago Visitor*, October, 1932, pp. 16–17, 40.

Speyer, A. James. "Twentieth Century European Paintings and Sculpture." *Apollo*, 84 (September, 1966): 222–25.

Sweeney, James Johnson. "La Peinture française moderne à l'Institut des Beaux-Arts de Chicago." *Cahiers d'Art*, 7, nos. 8–10 (1932): 334–36.

Sweet, Frederick A. "Carter H. Harrison as a Collector." *Bulletin of the Art Institute of Chicago*, 38 (September–October, 1944): 77–79.

———. "Great Chicago Collectors." *Apollo*, 84 (September, 1966): 190–207.

Watson, Forbes. "A Note on the Birch-Bartlett Collection." *Arts*, 9 (June, 1926): 303–12.

Wilenski, R. H. *Modern French Painters.* Vol. 2. New York: Vintage Books, 1960.

The Winterbotham Collection. Chicago: Art Institute of Chicago, 1947.

Zabel, Morton Dauwen. "An American Gallery of Modern Painting." *Art and Archeology*, 26 (December, 1928): 227–36, 245.